IMAGES
of America

PFLUGERVILLE

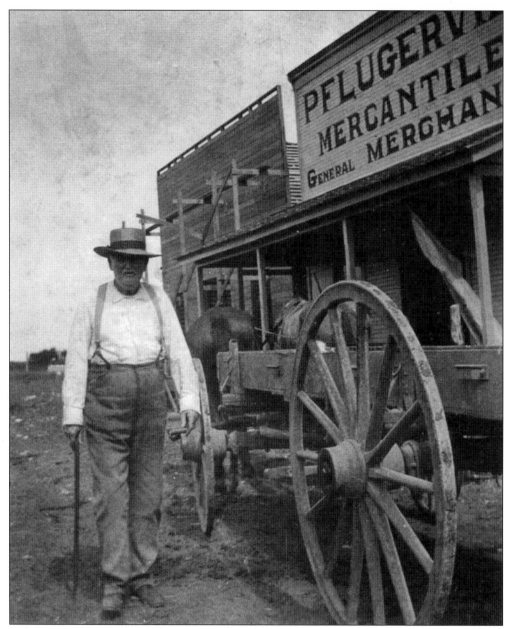

A driving force in Pflugerville's early development was George Pfluger, who, at age 14, arrived from Germany in 1849 with his older brother, 19-year-old Conrad. He donated land for the railroad right-of-way, the depot, and a school and encouraged businesses to build in the downtown area. He is shown here in the early 1900s on Main Street standing in front of the Pflugerville Mercantile. (Courtesy of Melrose Zimmerman.)

ON THE COVER: When cotton was king in this rural community, there were numerous cotton gins in the area. Otto Pfluger was a young lad when his father, O.C. Pfluger, owned the O.C. Pflueger & Brothers cotton gin. Round bales loaded in the back of the truck were common until 1939. The gin, built in 1904, burned in 1931 and was replaced with a more modern gin, which still stands today. (Courtesy of Melrose Zimmerman.)

IMAGES
of America

PFLUGERVILLE

Audrey T. Dearing, Vernagene H. Mott,
and Pamela A. Stephenson

ARCADIA
PUBLISHING

Published by Arcadia Publishing
Charleston, South Carolina

Printed in the United States of America

Library of Congress Control Number: 2013941693

For all general information, please contact Arcadia Publishing:
Telephone 843-853-2070
Fax 843-853-0044
E-mail sales@arcadiapublishing.com
For customer service and orders:
Toll-Free 1-888-313-2665

Visit us on the Internet at www.arcadiapublishing.com

To all who share the passion of preserving our history.

CONTENTS

ACKNOWLEDGMENTS

We are especially grateful for the wholehearted support received in compiling this book. Only a portion of the wonderful photographs we collected of the evolving Pflugerville community are included. Photographs were gathered from private collections and scrapbooks found in attics or garages; many of these images have never been seen by the community. They provide us with a glimpse of earlier times and the dramatic changes that Pflugerville has endured over the past 160 years. Thankfully, many lifelong residents shared their memories to ensure that our history is not forgotten.

For sharing their time, memorable stories, and treasured photographs, special thanks are extended to, in alphabetical order, Terry Ayers, Elvira Becker, Clarence and Leah Bohls, James Bohls, Treldon Bohls and sister Lexine Spillman (Treldon Bohls), Verline Bohls, Steve Bonner, Jeanette Burk, Alan Coovert, Lupe Mendoza (Davila family), Hildegarde Gebert, Frances Gibich, Janelle Hebbe (Harriet Hocker family), Janet Hees (Joyce Hees Stuewe), Robert E. and Dianna Johnson, LaNelle Knebel and daughter Jan Selman (Knebel and Lisso families), Eleanor Koester, Dorothy and Ray Kraemer, Gloria Kuempel and the J.L. Steger family, Gretchen Kuempel and daughter Gretchen Rye (Max Kuempel family), Pat McCord, Winnie Mae Murchison, Riley Parker, Alice Pfluger (Waldemar Pfluger family), Willie Robinson and daughter Arlene Cornelius (Robinson family), James V. Roy, St. Mary Missionary Baptist Church, Melanie Samuelson, Martha Sansom, Paul Schlesinger, Jan Spears, Myrna Swensen, Clifford Ward, Gladys Weiss, Lamar and Patricia Weiss, Pat Wieland (Fritz Wieland family), Linda Williams (Caldwell family), Herbert and Pat Wolff, and Melrose Zimmerman and son Byron.

Also contributing were the City of Pflugerville, Friends of the Pflugerville Library, the Heritage House Museum (HHM), Pflugerville Community Development Corporation, Pflugerville Independent School District (PISD), and Travis County. Many of the photographs were selected from the Eugene and Verna Hebbe collection (V. Mott).

We particularly wish to express our appreciation to Laura Bruns, our editor with Arcadia. Her patience and guidance has been invaluable.

Last, but not least, our families deserve our deepest gratitude as they provided us with patience, encouragement, and support, tolerating our redirection of many hours to complete this book. We are especially thankful for them.

INTRODUCTION

Often described by its motto, "Between a Rock and a Weird Place," Pflugerville is a rapidly growing community located in North Travis County, in central Texas, between Round Rock and Austin.

After 17 weeks at sea, the Henry Pfluger family arrived from Germany in the early 1850s and eventually purchased land in the Wilbarger Creek basin in the fertile Blackland Prairies. When Louis Bohls proposed to open a post office in his general store, he suggested the name Pflugerville, since the major landowners were Pfluger related.

In 1904, the Missouri, Kansas & Texas Railroad (MKT) came to Pflugerville, changing the community forever. Gilleland Creek was dammed, creating Katy Lake, to provide water for the railroad's steam engines. George Pfluger, son of Henry Sr., donated land for the depot and with his son Albert platted a downtown business area that contributed to community development. An area of 16 blocks, including the depot grounds for the MKT, created the downtown.

Cotton was king in Texas and was the cash crop for the farming community. Brothers William and George Pfluger built the first cotton gin and constructed wooden buildings for downtown businesses. William acquired the gin, and when the steam engine was perfected, he built a larger gin in town near the railroad. It continued to be operated by his son O.C. and grandson Otto Pfluger. Another gin was built by the Doerfler family. The gins processed tons of cotton daily during the fall harvesting season. Bohls' general store was moved east to be closer to the new center of activity.

The close-knit community survived the Great Depression by living off their land and sharing with neighbors. Nearby communities of Richland, Cele, Dessau, Rowe, Center Point, Three Point, and Highland shared in the education facilities, businesses, and railroad in Pflugerville.

With the expansion of the Austin boundaries nearing the community, the village of Pflugerville incorporated under a commission form of government in 1965. After an election in 1970, it changed to an aldermanic form of government.

Pflugerville continues to expand. From its rural population of 250 in the 1890s, Pflugerville has grown to 50,000 residents within its limits of 22.69 square miles. It continues to develop to the east, now encompassing an area of more than 40 square miles in its extra-territorial jurisdiction. In August 2012, Pflugerville was named one of the 100 best places to live in America by *Money Magazine*, confirming what the residents here already know: it is a city where "Where quality meets life."

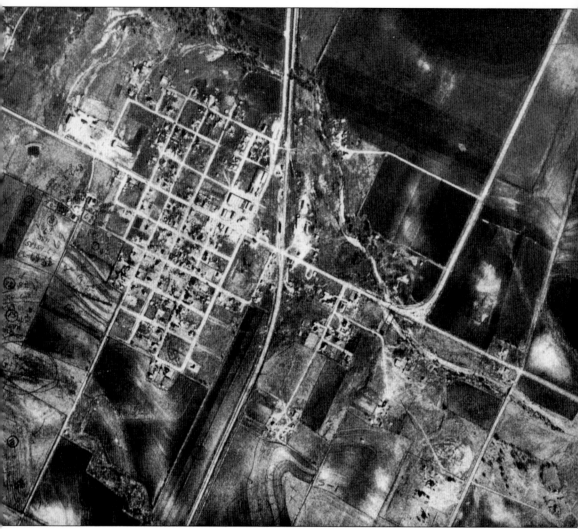

This 1958 aerial view shows the village much as George Pfluger planned it in 1904, with the railroad tracks traversing north to south, just east of the downtown area. The cotton gin is just east of the tracks, where they cross Pecan Street. Immanuel Lutheran Church is in the lower right of the photograph. (Courtesy of Travis County.)

One

SETTLING PFLUGERVILLE

Wars, revolutions, economic conditions, drought, and overpopulation were all contributing reasons for immigration to Texas. Settlers could often not read, write, or speak English. A conglomeration of languages was spoken by those who settled in the new land. In Pflugerville, there were many German dialects blended with English.

Germans sailed to Texas in the 1850s, settling in central Texas to farm the rich soil of the Blackland Prairies. Land was purchased from veterans of the Texas Revolution who had received bounty grants. The area was covered with tall sage grass, where buffalo were numerous and ignited chaos when they got into pens with milk cows. Native Americans, such as the Comanche, roamed the area searching for food and often did not get along with settlers; however, Lipan and Tonkawa chiefs would often stop by Merrill's store for a friendly chat. Southerners moved west to Texas in the 1860s, fleeing the Civil War. The Mexican Revolution of 1910 resulted in many traveling north into Texas to avoid serving with rebel forces. In addition, work on the railroad and on the farms attracted many to the area.

Early pioneer dog run–style homes were constructed of split logs nailed with wooden pegs. The smokehouse and porch had wooden floors, while others remained earthen. Meals were prepared on an open fireplace with iron skillets and Dutch ovens. Garments were hand sewn, using wool and cotton that had been cleaned, corded, spun, and woven. Water witchers were switched to find water.

The roads were dirt trails, frequently impassible in bad weather, causing horse-drawn carriages to repeatedly get stuck in mud during rainstorms. A common German comment was "*immer etwas*" (always something).

The introduction of the railroad in 1904 changed daily life for the small, rural community. The train allowed farmers to ship their products to market and brought passengers to the town for overnight stays, generating new businesses. MKT operated from 1904 to the 1970s, when the tracks were removed. Diesels replaced steam engines in the mid-1940s. Construction of new roads continues to promote growth, attracting families to move to the area from around the globe.

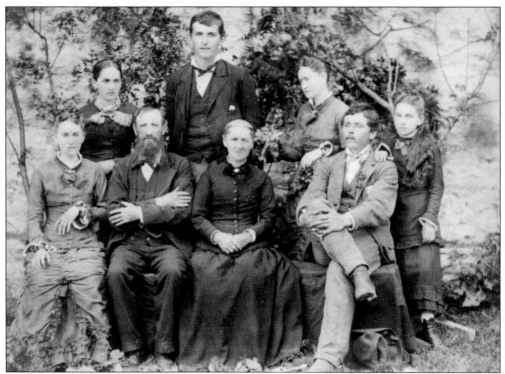

Henry Pfluger Sr. relocated to Texas from Germany in 1850. Encouraged to settle in Texas by his sons Conrad and George, who arrived in 1849, Pfluger, his wife Anna Christina Kleinschmidt, and family members landed in Galveston Bay. They settled on 960 acres in the Wilbarger Creek basin, where he died in 1867. Conrad met Swiss born Anna Wuthrich in Austin and married her in 1856, and they lived in a one-room stone cabin with a dirt floor on 200 acres purchased in 1870. A century later, it became the site of the Gatlinburg subdivision, an elementary school, little league fields, and the city wastewater treatment plant. Pictured above are the Pflugers. They are, from left to right, (first row) Dorothea, Conrad, Anna Elizabeth, and Peter; (second row) Emma, Ernest, Marie, and Anna Sophia. Below are, from left to right, Conrad's daughters Sophia, holding her son Henry; Marie, holding her son Kermit; James Fuchs; and Peter Pfluger. Conrad's wife, Anna Elizabeth, is seated. (Above, courtesy of Harriet Hocker family; below, Gladys Weiss.)

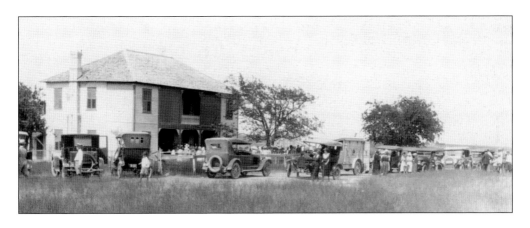

William Pfluger, arriving in 1852, married Franziska Sternberg in 1872, and they had six children. Now on Pflugerville Parkway, their 1875 two-story limestone rock home was built on the south bank of Wilbarger Creek. Today, the oldest structure in town, it was the first home with electricity in the area. William, an early founder of downtown Pflugerville, died in 1923. Family and friends gathered at the home (above), where he lay in state, and joined the two-mile-long procession led by a white hearse to Immanuel Lutheran Church Cemetery. Pfluger built the first bank and served as its president; he is also responsible for other business buildings in the newly platted downtown area. His son O.C. (below) drives the family, from left to right, Louisa, Anita, Helene, Hertha, Frances (on the floor), Lillie, Bernice, and Norma. (Above, courtesy of Clifford Ward; below, Melrose Zimmerman.)

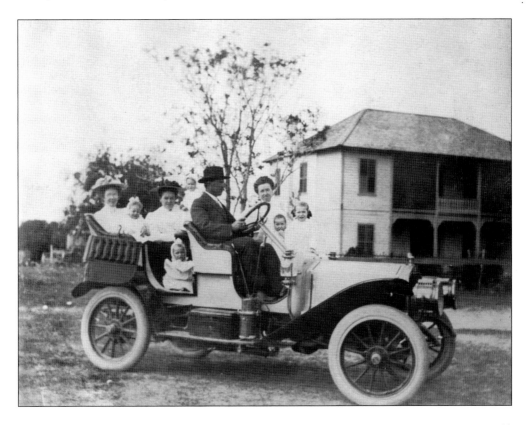

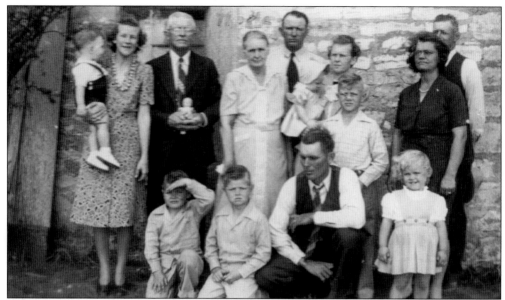

Conrad Pfluger's farm was purchased by Florenz J. (F.J.) Bohls. In front of the old Pfluger 1870 rock house in 1943 are, from left to right, (first row) Rodney and Gordon Rydell, Chester Bohls, and Karen Rydell; (second row) Blanche Bohls (holding Lanier), F.J. Bohls, Thekla Bohls, Arthur and Ella (holding Janelle) Hebbe, and Charles, Dorothy, and Hugo Rydell. (Courtesy of Treldon Bohls.)

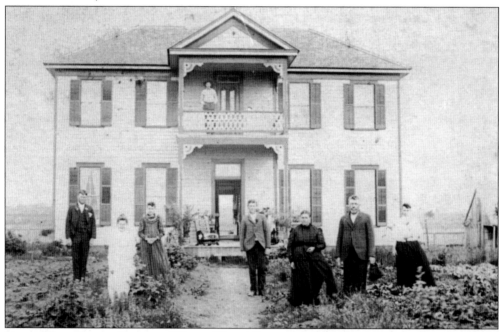

Henry Pfluger Jr., the first son of Henry Pfluger Sr., and his second wife, Anna Christina (front right), bought a farm east of Pflugerville in Center Point on Wilbarger Creek, where they raised three boys and seven girls. He erected a cotton gin on the property and co-owned, with Henry Bohls, the first steam thrasher. He died in 1904 and is buried in the Pfluger family cemetery. (Courtesy of Treldon Bohls.)

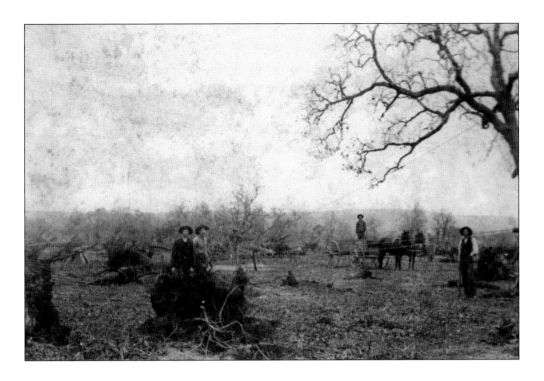

The 1880s photograph above shows workers clearing the land on the Henry Lisso farm using ropes, pulleys, and mule-driven wagons to pull down the trees. The Lisso family settled on land on Windscott Creek, now at the corner of Wells Branch Parkway and Immanuel Road. The first schoolhouse in the area was built on the farm in 1872. Lisso married Hermine Wieland, who was born in1842 in Anhalt, Germany, and immigrated to Texas in 1869. The original fieldstone home of her brother Martin Wieland still stands on Howard Lane. Granddaughter Norma Lisso served as associate postmistress of Pflugerville. Below, military units camped on the farm from 1914 to 1916. (Both courtesy of Knebel family.)

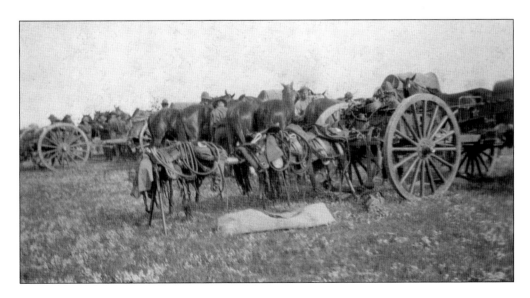

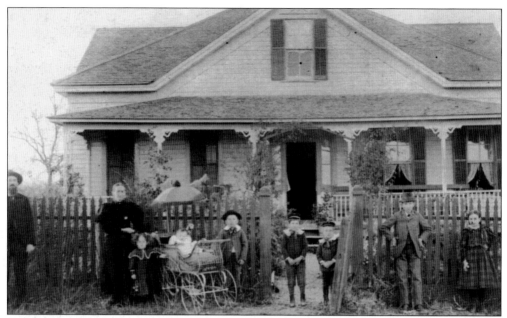

Seen here in 1898, James Fuchs and his family are on the farm east of Pflugerville. From left to right are James, Marie, Emma, Laura, Edgar, Emmitt, Adlai, Alfred, and Olga. Fuchs installed the first rural telephone system in order to communicate with his family. His grandson, 1st Lt. Kermit Fuchs, was killed on his 13th mission as an Air Force B-24 bomber pilot in Germany during World War II. (Courtesy of Clarence Bohls.)

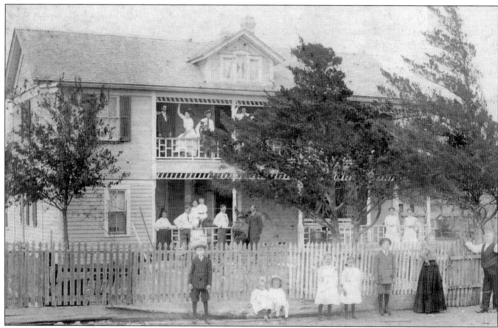

August Weiss (front right) and his wife, Caroline (second from the right), are seen in this 1910 family photograph. The 166-acre farm was purchased in 1881 for $7.50 per acre. Their first home was a two-room house that served as the kitchen and dining room on the north side of this new 1908 home. They were blessed with 15 children, four of whom died young. (Courtesy of Gladys Weiss.)

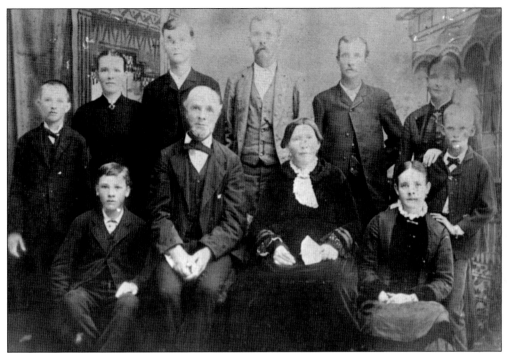

William Bohls and Catherine Pfluger, the first daughter of Henry Sr., married in 1852. They owned several farms before building a home on 205 acres purchased from her brother William. Bohls donated five acres of land for the Immanuel Lutheran Church, where both are buried. Bohls Place and Bohls Park carry the family name. Above are the Bohls posing for the camera. Pictured are, from left to right, (first row) Emil, William, Catherine, and Emilie; (second row) William, Annie, Louis, Henry, John, Lydia, and Edward. Below, Catherine's sister Marie Schmidt (with the head wreath) and her husband, Franz, celebrate their 50th wedding anniversary. Schmidt's neighbor, Mrs. William (Ida) Mahlow, sewed the black dress she wore at the 1911 event. In 1878, Schmidt provided an acre of land, on which the first school in Richland was built. (Above, courtesy of Clarence Bohls; below, Treldon Bohls.)

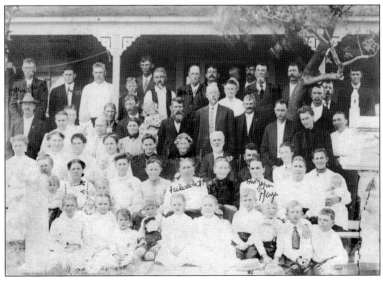

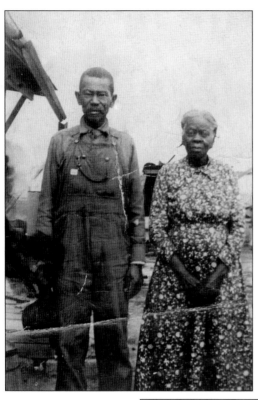

In 1910, African American workers in the cotton industry and the ice factory in Pflugerville were not allowed to live in town. They lived in the Pflugerville Colored Addition, located west of the city. Original settler families of the addition were George Caldwell (shown here with his wife, Kathryn), Thomas Doxey, Will Smith, Peter McDade, Ben Meeks, James E. Tyson, and Willie Allen. (Courtesy of Caldwell family.)

Inez Houston Russell was a faithful and active member at St. Mary Missionary Baptist Church since 1925, serving in the choir and as president of both the Deaconess ministry and Senior Mission ministry. She participated in the Travis County Home Demonstration program and the local community center. Having lived to be 100, she is buried in the cemetery Russel's Place to Rest, located in the Pflugerville Colored Addition. (Courtesy of St. Mary Baptist Church.)

Tommie Nell McDade (left) and Willie Robinson renewed vows on their 50th anniversary. The five youngest of their eight children graduated from Pflugerville High School. Before marrying, Robinson lived with his grandparents John and Queen Esther Reubottom Feamster, who arrived here in 1870 as the first African American family in the area. The Feamsters are buried on the 100-acre farm they bought in 1873 from horse breeder Judge Bell. (Courtesy of Robinson family.)

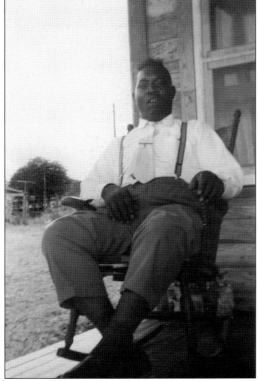

The Peter and Henrietta Lane McDade family settled in Pflugerville in the 1880s. Their grandson Albert (pictured), son of Phillip and Ida Delaney McDade, was a custodian and school bus driver for many years, served as deacon at St. Mary Missionary Baptist Church, and was a farmworker. Albert and Lula Burleson McDade were lifelong residents of the city. During segregation, unmarried African American female teachers lived with them. (Courtesy of Robinson family.)

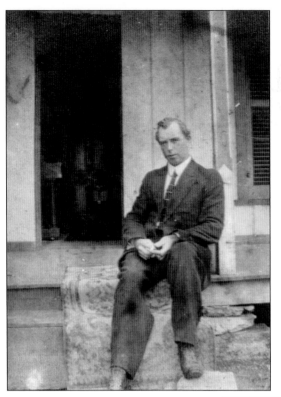

In 1910, La Rue Noton (at left) set aside about one acre of his 1,200-acre farm to create the Pflugerville Colored Addition, selling lots to black families for $50 each. When Travis County Commissioners tried to rename the area in 1978, property owners refused the move. Lots 1, 2, and 3 of Block A were sold to St. Mary Missionary Baptist Church on September 27, 1910, according to Noton's registry of sales (below). Lots were also sold to the Methodists and St. Matthews Baptist Church. Mexican families—including names suck as Cantu, Arreola, Flores, Gomez, Gonzalez, Guajardo, Guerra, Luna, Mejia, Mendoza, Ochoa, Mercado, Perez, Ramos, Reyes, Riojas, Salazar, Silba, Silva, and others—collected money from fund-raising dances and donations to buy one acre for $100 from Noton in 1924 for the San Camilo Cemetery. Renamed Santa Maria Cemetery in 1965, it received a historical marker in 2003. (Both courtesy of Clifford Ward.)

Ward Rural Telephone Co.

Pflugerville, Texas

R. A. WARD, MANAGER
LaRue Noton, SEC'Y-TREAS

Lot 1, 2, 3 Blk "a"		Mary's St. John's Missionary Baptist	9-27 1910
" 1 " B		Thos Doxey	9-20 1910
" 2 " B			1910
" 3	B	"	1910
" 4	B	Ben Meeks	1910
" 5	B	" "	1910
" 6	B	" "	1910
" 7	B	Jim Harmon Methodist 1-24	1911
" 8	B	Wm Meeks	1910
" 9	B	Lillie Marshall	1910
" 10	B	Ross Meek's	9-20- 1910
" 11	B	Ross Meeks	10-14- 1910
" 12	B	Mack Wallace	10-14- 1910
" 1	C	James E. Tyson	10-5- 1910
" 2	C	" "	1910
" 3	C	" "	1910
" 4	C	" "	1910
" 5	C	Lizzie Graham Delinquent for year 1912 Jan 21-	1911
" 6	C	Mack Collins	" 1911

Paid taxes 1.05 and
mul costs 4.50 on
lot 6 Blk C
date Oct 1916

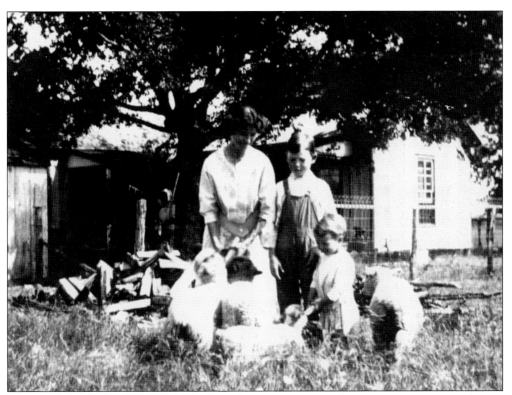

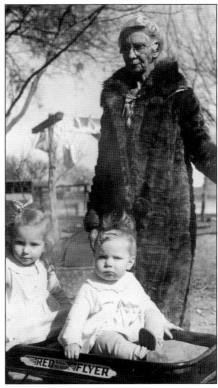

Above, Clifford and Myra (right) Ward are shown with their mother, Myrtle, on the homestead farmed before 1880 by Hiram Ward, Clifford's great-grandfather. At right, grandmother Maudine Ward, in her fur coat on a windy wash day, is with Myra (left) and Clifford in their Red Flyer wagon. Richard A. Ward and La Rue Noton established the Ward Rural Telephone Company in 1909, sold to Southwest States Telephone Company in 1928, and then sold to Southwestern Bell in 1953. (Both courtesy of Clifford Ward.)

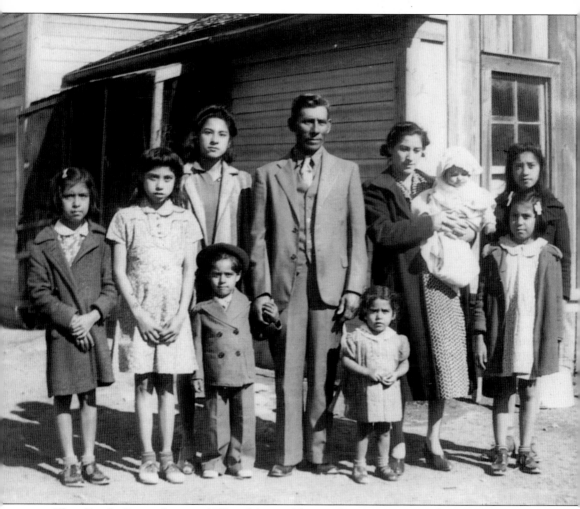

Cleto Davila Sr. was born in 1892 in Mexico. Fleeing the oppressive conditions of the Porfirio Diaz regime, he, his parents, and siblings came to Texas, settling in the Pflugerville area hoping to fulfill their dreams of a better way of life. In 1926, he married Texas-born Felicita Rendon. They were blessed with six daughters and one son. The couple purchased a home from Grover Kuempel that had been the first parsonage of the Lutheran church. All of their children attended Pflugerville schools, with Cleto Jr., a star athlete, and Lupe graduating from Pflugerville High in 1957. Lupe married Ray Mendoza, a descendant of the Mendoza/Guajardo family. The family worshipped at St. Elizabeth's Catholic Church. For decades, Felicita was a caretaker of the historic Santa Maria Cemetery, was active in the Parent Teachers Association, and was president of the May Fete activities at the Mexican-American School. From left to right are Lalla, Pauline, Jean, Cleto Sr., Felicita, Margaret, Louise, and Mary; the small children in front are Cleto Jr. (left) and Lupe. (Courtesy of Davila family.)

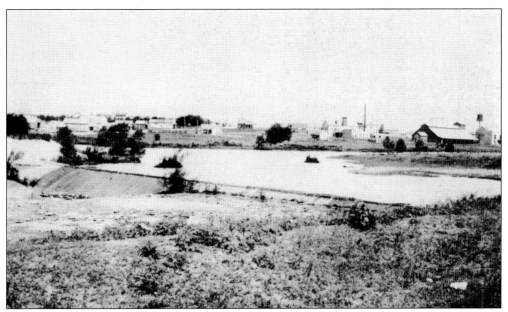

The introduction of the railroad brought change to the rural community. To provide a water supply for steam engines on the MKT Railroad, a dam was built on Gilleland Creek in 1904, creating Katy Lake. The lake was also a destination for recreation until the flood of 1921 washed away the dam, returning the creek to its natural state. The town and gin are seen in the background. (Courtesy of Treldon Bohls.)

In this image, the MKT Railroad train stops at the Pflugerville depot in the 1920s. Passengers boarded on the west side of the train at the depot located on Railroad Avenue in the downtown area. Children ran downtown when they heard the train whistle, anxious to see who had arrived and to collect any mail. (Courtesy of Waldemar Pfluger family.)

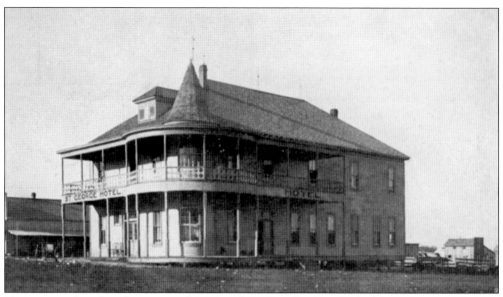

To accommodate the salesmen, cattlemen, and visitors who disembarked from the trains, George Pfluger built the St. George Hotel in 1905. At a cost of $3,000, the hotel, near the depot and just east of Railroad Avenue, offered 17 to 20 guest rooms and hosted parties and masquerade balls until it burned in 1916 when an oil lamp fell, resulting in a fire that destroyed the landmark. (Courtesy of Treldon Bohls.)

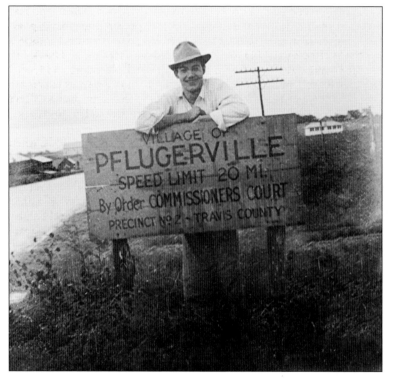

In this 1938 photograph, Martin Ayers is on FM 1825 when it was a dirt road that approached town from the west. To the left of Ayers are the Civilian Conservation Corps camp (CCC) and the Rock Gym, built by those living in the camp. On the right is the Mexican School on the Ernest Pfluger farm, near the present-day Pflugerville Public Library. (Courtesy of Terry Ayers.)

Two

FARMING THE LAND

Farming the rich Blackland Prairie was the primary business in the Pflugerville area for over a century. Early settlers with farming backgrounds were attracted to the area for its flat terrain and fertile soil. Large families were an asset, with old and young members alike providing much of the needed labor to care for the livestock and crops.

The 1880 US agriculture census recorded crops of cotton, Indian corn, oats, wheat, and hay. Landowners often depended on tenant farmers and sharecroppers to prepare the ground, plant the crops, harvest the yield, and share in the profits. They put in long days. Cotton was picked by hand, put in long sacks made of heavy ticking, weighed, loaded onto trailers, and hauled to the cotton gin for processing for market. Hay was cut, stacked in shocks by hand, and loaded onto trailers. Known as exchange work, neighbors often helped each other get crops harvested, with money never changing hands. Farmers frequently struggled with the problems of boll weevils, bollworms, aphids, grasshoppers, thrifts, drought, and hailstorms, as well as fluctuating market prices.

Mule teams and human labor were all that was used to farm the land until the 1930s, when farmers began using the tractor and mechanized equipment, such as thrashers and combines. Corn pickers became available in the 1950s and cotton pickers in the 1960s.

Each farm had a vegetable garden and fruit orchard, typically growing enough to feed the family and at least three other people. Meals included vegetables harvested that day or canned from the previous season. Families raised chickens for eggs and meat, turkeys for special holiday meals, and hogs for sausage, bacon, ham, and lard. Soap was made from the animal fats. Cream was separated from the milk and churned for butter, with the excess sold in the area. Round Rock Cheese Company picked up cans of milk from farmers daily to be processed as cheese.

Rail access became available in 1904, providing a means of transporting products to available markets and promoting farming as well as business growth in Pflugerville.

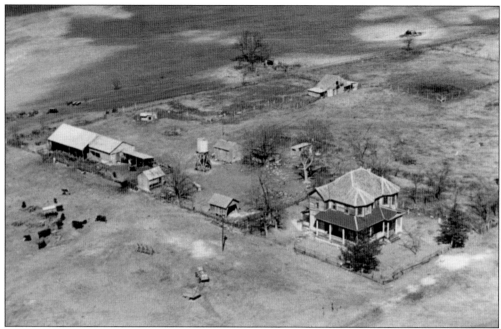

In this 1910 image, the Charles C. (C.C.) Kuempel farmstead near Gilleland Creek shows the many buildings on the typical farm. As a lad, Kuempel watched cowboys run thousands of longhorn steers to market on the Chisholm Trail near his farm. He witnessed conflict between sheepherders and cattlemen and raging sage grass fires. The fertile furrows are now covered by the Arbor Creek subdivision, symbolic of the urban sprawl that has transformed much of the area. (Courtesy of Herbert Wolff.)

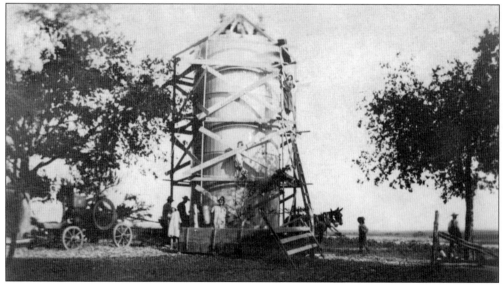

Silos provide essential space for storage of a bountiful harvest. Gottlieb C. (G.C) Pfluger's silo was built of cypress wood, standing 30 feet tall and nine feet in diameter, with 5/8-inch steel cables wrapped around it for support. Silage was blown through a seven-to-nine-inch pipe connected to a small door at the top. Pfluger's son and nine daughters are seen here as they climb on the scaffold. (Courtesy of Lamar Weiss.)

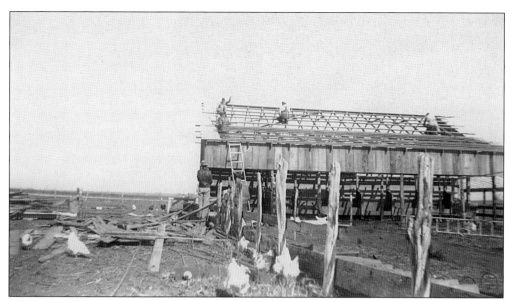

In 1945, neighbors have gathered for a traditional barn-raising on the Eugene Hebbe farm. The loft will store hay, and four large rooms below will provide storage for the harvest. Cedar posts form the boundary for the cow lot, while chickens roam freely in search of insects, worms, and grass. Men, women, and children worked side by side through sweltering heat and bitter blue northers. (Courtesy of V. Mott.)

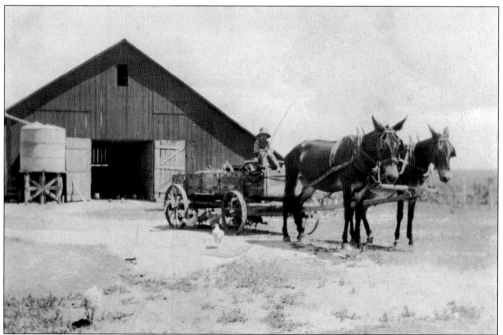

Marion Pfluger guides his mule team with a harness and blinders. A good mule was a highly cherished possession, necessary to make a living on a self-sufficient farm. The rain collection system captured water from the barn roof with gutters channeling it to the cistern to be used for cooking, bathing, washing clothes, and watering the garden. Farmers watched, predicted, and depended upon the weather. (Courtesy of Jeanette Burk.)

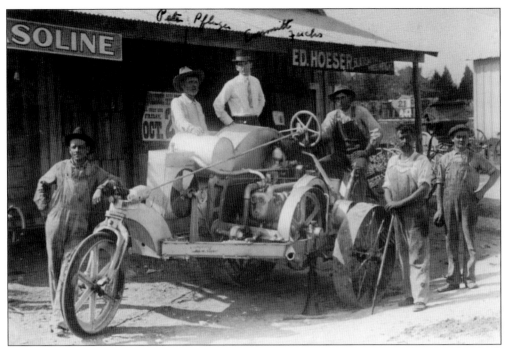

It is a proud moment for Peter Pfluger (left) and Emmitt Fuchs, shown in white shirts, as they look over their first gasoline-powered Big Bull tractor. It had a long steering column, a front rubber tire, and iron wheels on each side. Mechanical equipment was making farming somewhat easier and more efficient during this era. (Courtesy of Treldon Bohls.)

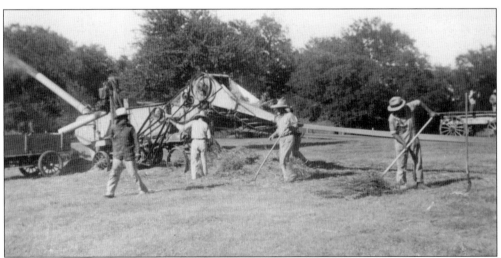

Some farmers invested in an International Harvester thrashing machine and frequently traveled to neighboring farms to thrash oats. Pitchforks were used to throw the crop into the feeder, where a conveyor belt took it into the machine, eventually blowing out the chaff. The all-day activity would begin after the dew had lifted. (Courtesy of Treldon Bohls.)

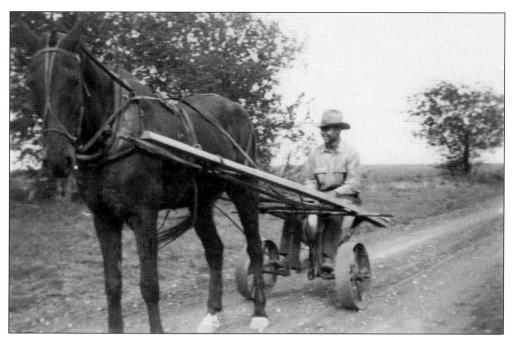

Eugene Hebbe rides on a two-row, iron-wheel roller used to roll over the furrow to pack the soil after planting seeds. This practice increased the percentage of seeds that would sprout, grow, survive, and produce. Farms were devastated during the record 1957 drought, with sustained heat scorching the earth and killing grass and trees. (Courtesy of V. Mott.)

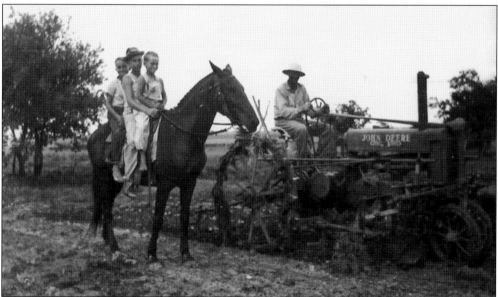

Alfred Steger, on his John Deere tractor with four iron wheels and a loud muffler, breaks from preparing the ground for planting to talk with, from left to right, Curtis, Florenz, and Alton Steger, who arrived on Mike the mule. Motorized vehicles took practice in cranking to start, using the clutch to switch gears, steering, and braking. Farmers struggled through the Depression, fluctuating markets, and weather calamities, with some losing their farms. (Courtesy of Hildegarde Gebert.)

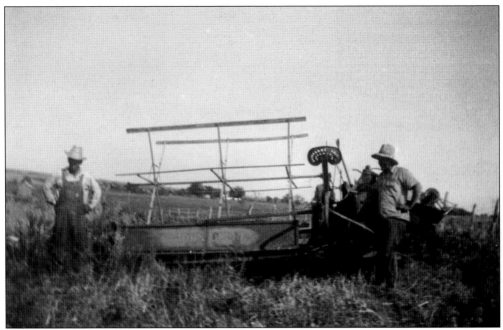

Bundles of oats are tied with twine and dropped to the ground; the family follows to stand the bundles upright, forming shocks. After drying out, the shocks are taken to the barn or left until the thrasher arrives. Henry Pfluger (left) and Eugene Hebbe are a team, with one driving the tractor and the other operating the reaper levers and gears. (Courtesy of Lamar Weiss.)

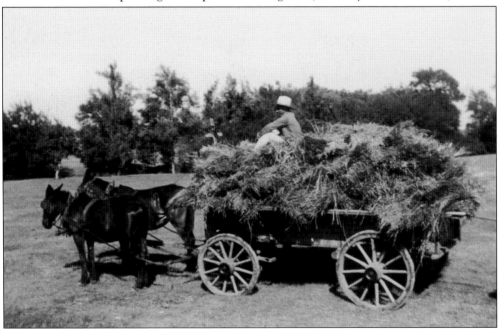

Seen here in 1943, Emmitt Fuchs has his wooden wagon loaded with hay at his farm in the Center Point area. The hay was brought in from the field to form a mountainous haystack near the barn. Farmers protected themselves from the intense Texas sun with wide-brimmed straw hats, bonnets, and long-sleeved shirts purchased at the mercantile. (Courtesy of Treldon Bohls.)

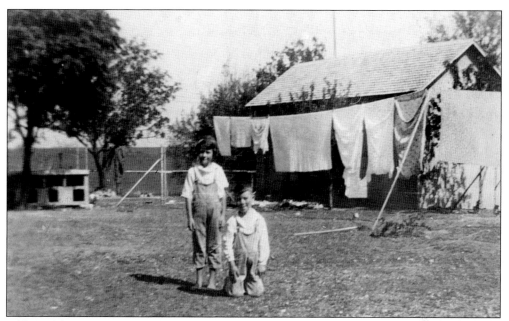

Siblings Blanche (left) and Milton Fuchs play on a Monday wash day. Clothes are sun-drying on a line held up by poles. Water, heated in an outdoor iron cauldron fueled by firewood, was carried to the washhouse to use in a wringer machine. Whites were washed first, with bluing added to the rinse water, then colored garments, and finally the denim overalls and gray work shirts. (Courtesy of Treldon Bohls.)

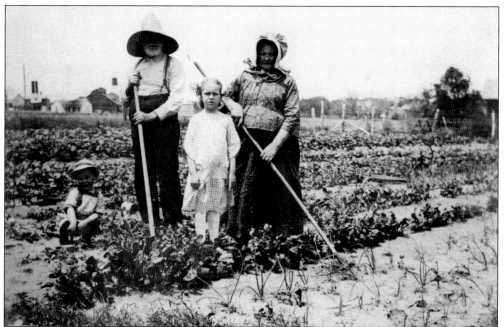

Each farm had a garden, providing the family with fresh vegetables and fruits picked daily and prepared for the meal. Large harvests were canned for use during off-season. Planting depended upon zodiac signs in the almanac or moon phases. Potato rows were nearly 100 yards long, with the harvest stored under the house. (Courtesy of Melrose Zimmerman.)

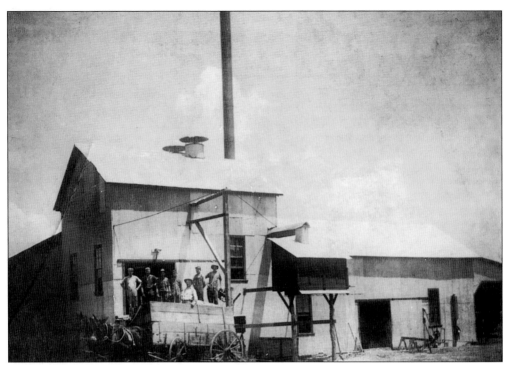

After the Civil War, cotton was king. In the early 1900s, two gins were built: the Doerfler (above) and the Pflueger. Both were close to the MKT Railroad for easy shipping of the cotton to market in Galveston. The "sucker" took the cotton from the trailer into the ginning process, as shown above. A full trailer of 1,800 to 2,000 pounds of picked cotton would be ginned, removing the seed, and then compressed into bales weighing about 500 pounds each. It was common to harvest and gin 5,000 round or square bales during a harvest season, which ran from September to March. Severe weather (below) caused destruction to trailers loaded with cotton. Weather could be a life-changing event, such as the severe twister in 1921 or the 1925 drought. (Above, courtesy of HHM; below, Clarence Bohls.)

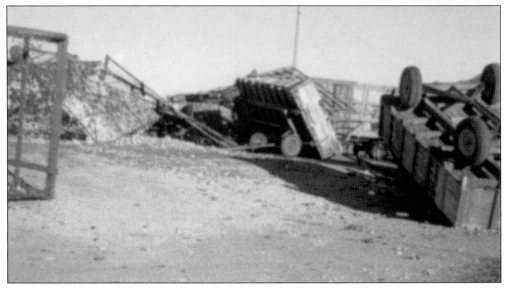

Owner and operator Otto Pfluger checks machinery in his cotton gin to prevent accidents. During the peak season, Pfluger was sometimes challenged to find enough workers for the operation, which ran 24 hours a day, 7 days a week. Farmers were anxious to have their harvest ginned quickly to get the empty trailers back to the field to be refilled. Entire families were expected to work in the fields, planting and harvesting crops. Sacks eight-feet long made of cotton duct and braced over the shoulder were dragged on the ground as cotton was picked and stuffed into the sack. A full sack weighed 80 to 100 pounds. In the 1918 image below, the barefooted Bohls children—from left to right, Dorothy, Chester, Raymond, Ella, and Mildred—are ready to fill their short sacks. (At right, courtesy of Melrose Zimmerman; below, Treldon Bohls.)

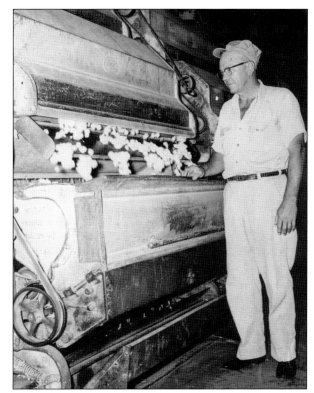

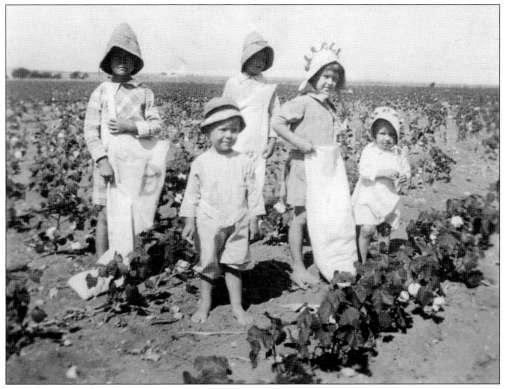

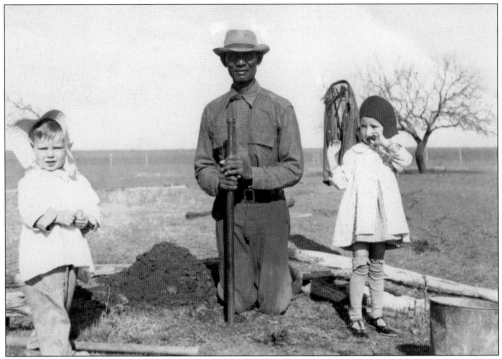

Clifford (left) and Myra Ward watch as farm laborer Felix Caldwell positions a fence post. Mechanical development of the cotton stripper and stripper trailers replaced the need for hiring pickers, but many of the laborers lived a lifetime on the farm. In the 1930s, one farmer harvested 51,100 pounds of cotton, which, at $2.00 per 100 pounds, cost $1,022 for picking. (Courtesy of Clifford Ward.)

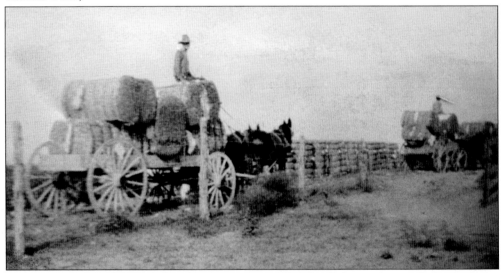

After being processed and baled at the gin, cotton was then hauled, in early years by horse-drawn wagons, to the market or returned home to wait for prices to improve. Pickers from the Rio Grande Valley resided in "hand" houses during the harvest season, usually beginning in early fall. In 1935, there were more than 3,000 farms in Travis County; in 2013, there were only 558. Thousands of acres have been lost to development. (Courtesy of Harriet Hocker family.)

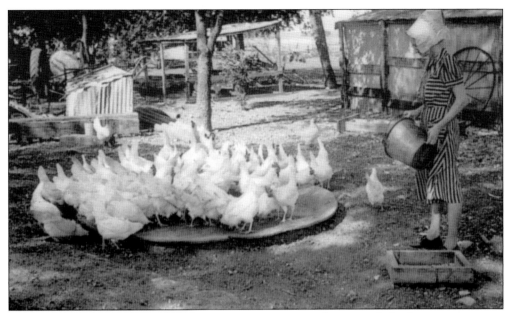

Women were in perpetual motion from sunrise to sunset with various daily chores necessary to sustaining life on the farm. Laura Bohls, wearing her bonnet for sun protection, feeds grain to her white leghorns. In the afternoon, eggs were gathered from the chicken house and coops in the background. Sometimes collected in aprons, eggs could be traded at the local mercantile for other necessities. The versatile apron worn by women wiped tears, carried eggs and vegetables, and were highly functional. (Courtesy of Clarence Bohls.)

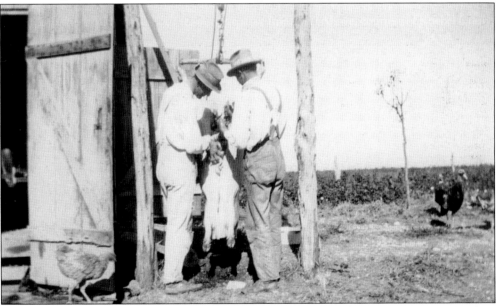

Cold days were perfect for butchering a corn-fed hog. Tall poles were used as hoists for the slaughter and scraping, with skilled hands separating muscle and tissue with precision. Using all parts (except the squeal) of the carcass—hams, hocks, bacon, pork chops, roasts, ribs, and sausage—the farmers filled the smokehouse with cured food. Cracklins were made in the wash kettle by frying the cubed pieces of fat. Lard and soap were by-products of processing. (Courtesy of V. Mott.)

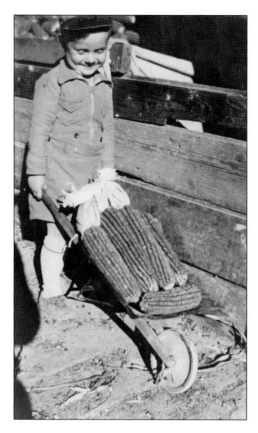

Children helped with numerous chores on the farm. At left, a young Hubert "Hub" Kuempel uses his small wheelbarrow to transport the large Indian corn harvested. More recently, farmers arranged educational field trips to the Hamann farm for elementary students, demonstrating farm equipment and how products such as corn and cotton are processed. Below, in the 1930s, the Kuempel children pick fruit that their mother, Alvina, will use to make jam, juice, and preserves. Early US census reports listed the number of fruit trees on each farm, with the most common being peach, pear, plum, and fig. (Both courtesy of Melanie Samuelson.)

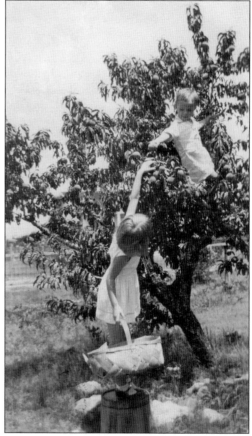

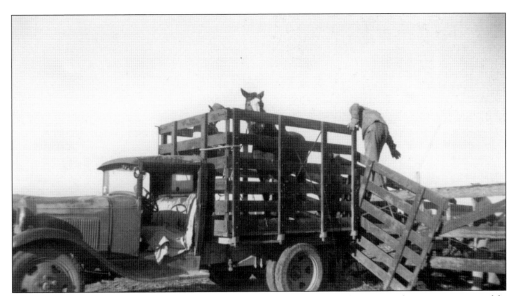

Eugene Hebbe (above) single-handedly loads a horse into the back of a truck. Farmers were able to do a multitude of critical tasks, including blacksmithing, construction, repairing machinery, and birthing calves. Stock was hauled to auction barns where there was a chorus of cattle huffing, puffing, and pounding hooves stirring up dust, along with the clanging and banging of metal gates opening and closing as workers allowed animals in and out of the ring. The rambling auctioneer bellowed into the microphone, capturing the attention of buyers and sellers in the arena as the highest bidder secured the sale. Ella Pfluger (below), the oldest child of Albert and Sophie Pfluger, learns to drive the farm truck. She is seen here transporting a Hereford calf. Pfluger lived to age 103 and remembered stories told by her grandfather George, which she shared with her family. (Above, courtesy of V. Mott; below, Eleanor Koester.)

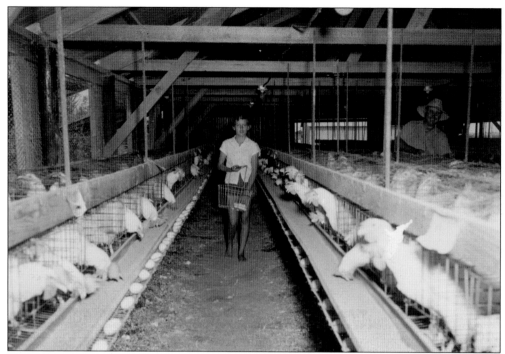

During the severe drought of the 1950s, farmers diversified to survive. Several of them built large poultry houses to accommodate 1,000 laying hens in individual cages. Daily chores included feeding them twice daily, gathering eggs in the evening (Vernagene Mott, above), and marking each hen's production with a small washer. Non-producing hens were culled. Buckets of eggs were cleaned in an egg-washing machine, dried, candled for purity, weighed, and graded for size. Twice weekly, eggs were boxed for marketing to St. David's Hospital and Sam Slaughter food stores in Austin. Quarterly, the chicken droppings were removed with large shovels and used for fertilizer. During the intense and relentless August heat, the aisles and roof were sprinkled with water in hopes of protecting the hens from heat stroke. Potatoes harvested from the garden (below) would be stored under the porch, where it was cool and dark. (Above, courtesy of V. Mott; below, Hildegarde Gebert.)

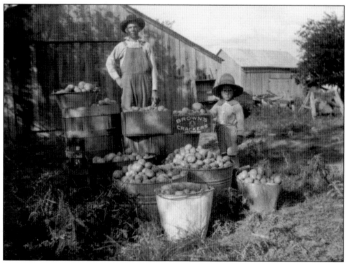

Three

ESTABLISHING BUSINESSES

In the early 1890s, Bohls & Eisenbeiser Meat Market, located on Gilleland Creek, became the official post office for the newly named community of Pflugerville. Until then, families received their mail at Gregg, Merrilltown, Round Rock, Hutto, or Manor, whichever was closest to their farm. With the arrival of the railroad in 1904, George Pfluger and his son Albert platted a town site a short distance to the west of the market.

The MKT Railroad spurred growth for the newly formed village. Land for the railroad right-of-way, the depot, and a school was donated by early settler George Pfluger. In 1906, William Pfluger, the younger brother of George, established the first bank on Main Street. That same year, La Rue Noton and Archie Ward set up the first telephone company for the area. Hotels and boarding houses were established to accommodate the hundreds of passengers who would disembark the trains and spend the night during these times. The young town expanded quickly.

Trades Day ads were sponsored by local merchants for the event held every Saturday during the Great Depression years. The event provided an opportunity for people to bring their goods to be auctioned off. Paper fans were produced to advertise businesses or products, which also served a useful purpose, especially during the hot summers. Wood and metal tokens were used by various businesses to offer discounts and were often collected by customers.

Plans were announced in 1917 for the construction of US 81, replacing Highway 2, and linking Pflugerville to Dallas, Austin, and San Antonio. Growth continued, with the population reaching 500 residents, until the Great Depression slowed progress. A record drought in 1957 forced businesses to close and young folks to leave town to find jobs. Interstate 35 was opened in 1962, bringing further change. By the 1990s, Pflugerville began expanding again because of its close proximity to the burgeoning city of Austin to the south. In the past 10 years, Pflugerville has experienced a 247 percent new-development growth rate, attributed to new toll roads Texas State Highway 130 and 45, established from 2006 to 2008. By 2013, the city declared 50,000 residents in its city limits.

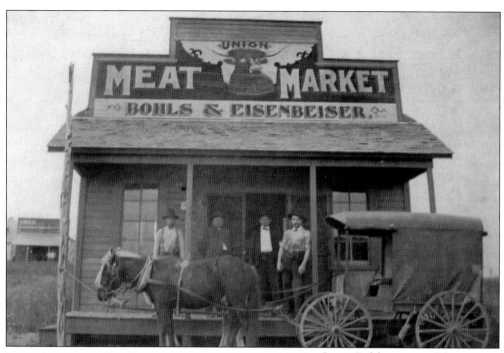

PFLUGERVILLE, TEXAS.

Louis Bohls, owner of the small country store Bohls & Eisenbeiser Meat Market, was granted the charter for a post office in 1893. Bohls moved his store west to be closer to the newly created business district. His grandfather Dietrich Bohls settled and built a cluster of cabins in the Barton Creek area west of Austin, recognized as the only habitation between Oak Hill and the Pedernales River. (Courtesy of HHM.)

George Pfluger and his son Albert platted the town site of Pflugerville on February 19, 1904. The public grounds and streets consisted of 16 blocks, with the right-of-way and the depot grounds for the MKT Railroad included. The depot served as the economic engine, generating businesses to grow in the new town. The first housing addition, six blocks known as the Wuthrich Addition, soon followed. (Courtesy of HHM.)

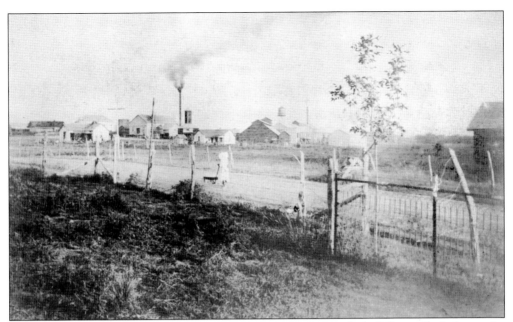

In this 1910 image, a young girl pulls her wagon down a dirt road, with the Pflugerville skyline in the westward distance. In the center is the Pflueger & Brothers Cotton Gin, the oil mill, and homes to the east, the present site of First United Methodist Church. (Courtesy of Melrose Zimmerman.)

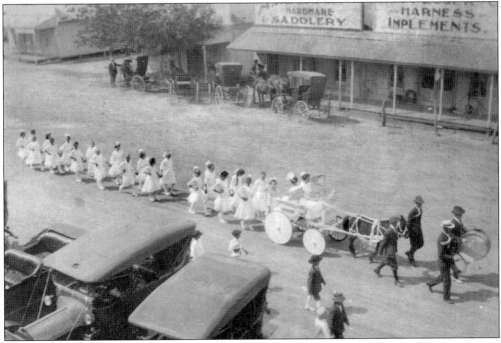

During the early 1900s, the community enjoyed putting on parades to celebrate holidays. Young girls dressed in white march down Main Street behind the May Fete queen riding in a decorated buggy. Automobiles parked on the south side of the street, while the horse and buggies parked on the north side. Many residents held multiple jobs, such as Otto Weiss, who ran a tin shop, a blacksmith shop, and bartended. (Courtesy of HHM.)

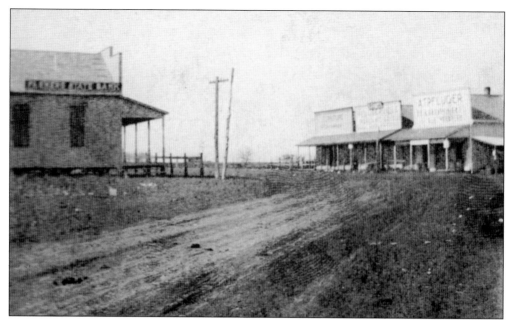

Farmers State Bank (left) was built by William Pfluger, who was also the president. The wood building burned down and was replaced with a two-story redbrick structure. Across the street were Pflugerville Mercantile and the A.T. Pfluger Hardware & Lumber Company, presently the site of Hanover's. August T. (A.T.) Pfluger opened his store in 1904, selling buggies, lumber, and supplies. (Courtesy of Treldon Bohls.)

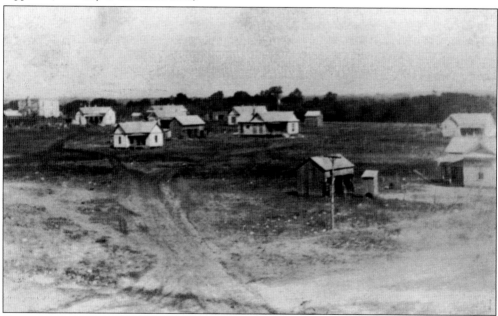

Business owners began building homes near the newly established downtown district. The wood-frame residences were on large lots with rainwater collection from gutters into cisterns. Most families had a cow to milk and chickens for eggs and meat. At the top left is the white brick school, built in 1907, located north of Wilbarger Street and south of Gilleland Creek. (Courtesy of Clarence Bohls.)

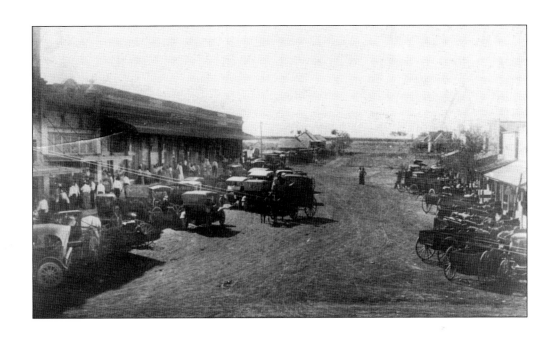

Above, in 1920, Main Street (seen facing west) was a wide, unpaved thoroughfare. Businesses flourished on Saturdays, when the surrounding community came by car, buggy, or wagon to get needed supplies and to see neighbors and friends. The handsome two-story brick buildings lining the south side of the street were occupied by Imken & Neese Drug Store, the Mercantile, PBK's, and Leppin's. The original wood-frame structures on the north side included the hardware store, livery stable, and blacksmith shop. Below is a deserted Main Street (looking east) on a snowy day in the 1920s. From left to right are A.T. Pfluger Hardware, Pflueger Gin, Will Bauer Oil Mill, the depot, and the bank. (Above, courtesy of HHM; below, Waldemar Pfluger family.)

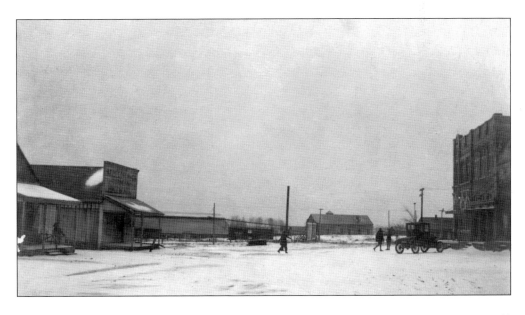

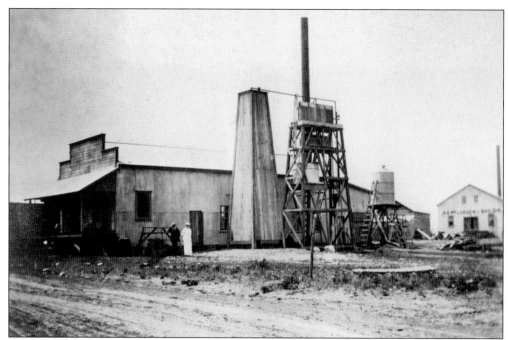

The ice factory seen above was built by brothers O.C. and Christian Pfluger in 1913 at a cost of $8,000. It operated until the 1940s, when it was closed and torn down. An engine, a tank, and storage were necessary for the operation of the factory. The three-day process of creating ice kept the water in motion as it froze so air bubbles escaped. Impurities freeze at a slower rate than the water, so the trick was to remove the water in the center just before it froze and replace it with distilled water. Blocks were stored underground or under the porch in the forms covered with sawdust. Below, from left to right are Emilie and August Pautz (cobbler), and Hertha, Otto, and Helene Pfluger. Rural customers preferred to pick up their ice on Sunday. (Both courtesy of Melrose Zimmerman.)

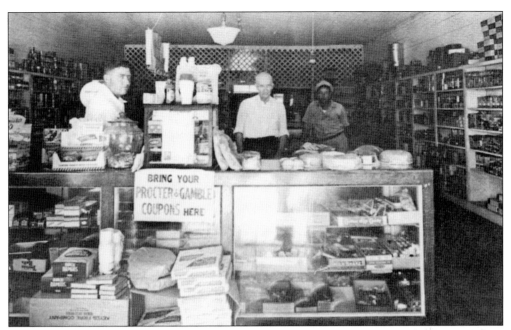

The Dornhoefer Red and White Grocery store, established in 1906, was located on Pecan Street, between the Pflueger and Doefler cotton gins. It burned down in the 1950s. From left to right are Aaron G. "Buck" Saegert, August Dornhoefer, and Atlan Albers in the late 1940s. A week of groceries cost $1. (Courtesy of HHM.)

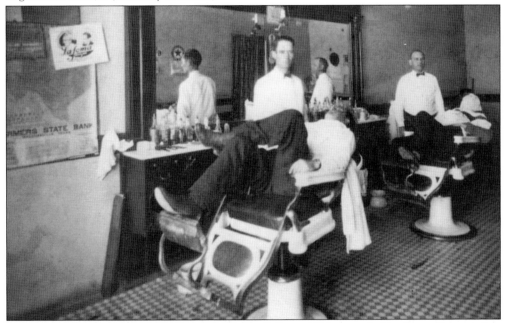

Claud Mayal Parker (right) was born in Marble Falls in 1886, attended barber college in San Antonio, and joined Edwin DeLeon as the Pflugerville barber in 1909. After four years, he bought the shop adjacent to First State Bank, where he barbered until 1972. He married Dora Weiss, who was an outstanding cook and creative seamstress, sewing specialty outfits such as cheerleader uniforms. (Courtesy of Riley Parker.)

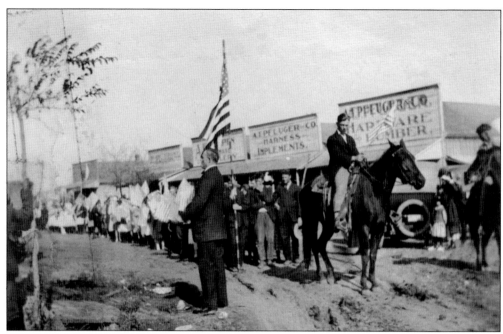

Superintendent Meadows (above) speaks during the 1918 Armistice Day parade on Main Street, celebrating the end of World War I and the return of the young men from the European battlefront. Leading the parade is Alfred Lisso on his horse. The parade (below) passes the Brooks Hotel on the north side of Main Street. The horse and carriage are decorated, and a business owner markets a large cistern for water storage from Leppin's. (Above, courtesy of Clarence Bohls; below, Knebel family.)

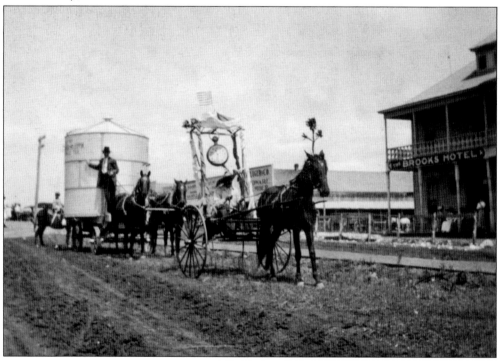

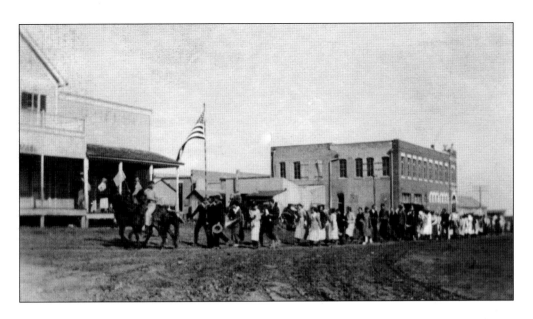

The Armistice Day Parade in 1918 continued south on Railroad Avenue (above), with citizens of all ages celebrating the end of the "war to end all wars." In the background are Farmer's State Bank and Prinz Brothers Fancy Grocery. The parade turned west onto Pecan Street (below). Behind the grocery store was the Sky Dome Theatre, owned and operated by Herman H. Pfluger from 1912 to 1928. Motion pictures were shown on Friday and Saturday nights, with music provided by a self-player piano. Steger Top Notcher is seen behind the theatre. (Both courtesy of Knebel family.)

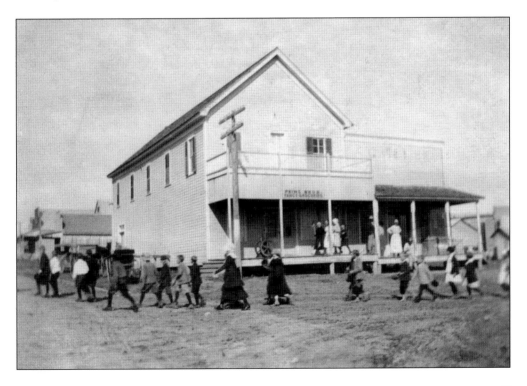

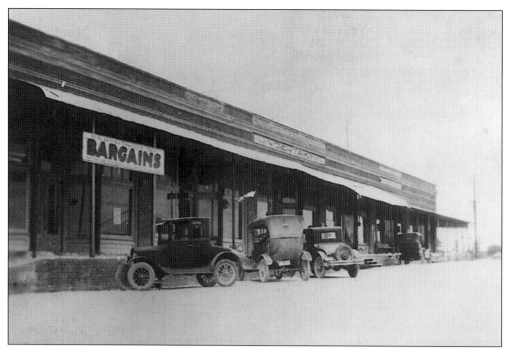

Leppin's opened in 1908 next to the Pflugerville Mercantile on the north side of Main Street. August F. Leppin established a thriving hardware store, adding wagons, buggies, furniture, windmills, and oil stoves over the years. He later moved across the street to the new brick buildings on the south side of Main, remaining in business until 1953. In the 1920s, he sold coffins and provided funeral services. (Courtesy of HHM.)

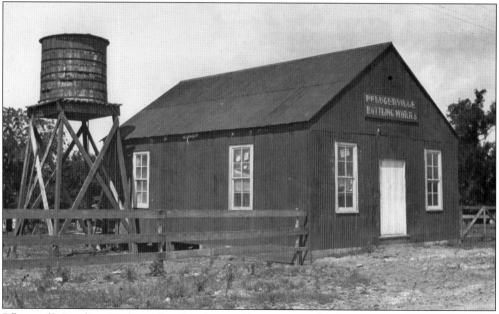

Pflugerville Bottling Works produced carbonated beverages made of pure cane sugar, pure flavoring, and carbonated water. First operated by Monroe Kriedel, Ed Knebel bought the business and moved it to Austin in 1927. (Courtesy of Knebel family.)

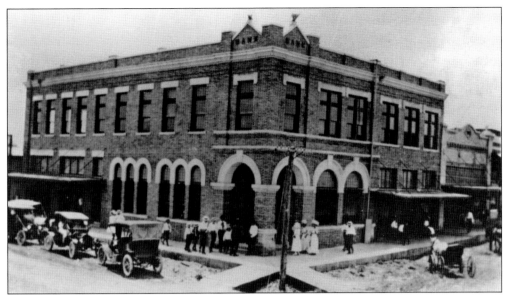

The financial crisis of the Great Depression resulted in Farmers State Bank closing on January 7, 1933. It opened the next day as First State Bank of Pflugerville. Its motto was "small enough to know you, large enough to serve you." The building is still in use at the corner of Main Street and Railroad Avenue. In 1965, the bank was robbed; $10,000 cash and valuables were stolen from the safety deposit vault. (Courtesy of HHM.)

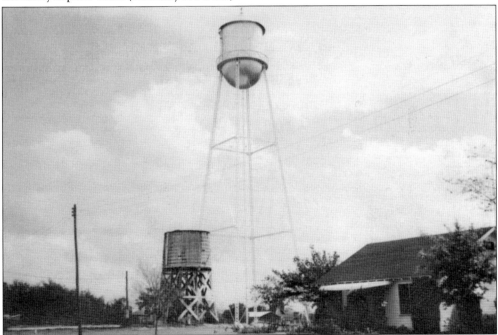

Early homes collected rainwater from rooftops into cisterns for everyday use. Due to drought, Pflugerville's first water tower, which was constructed of cypress wood, was installed by Otto Pfluger, who owned two wells. He purchased the taller tank from the Midwest to provide the pressure needed by the growing community. The waterworks was sold to the city in 1974. The landmark is located on Second Street South. (Courtesy of V. Mott.)

Knebel Brothers Confectionery Shop (above) was started in 1919 by Ed and Paul (P.B.) Knebel, selling ice cream and candy. After Prohibition ended in 1933, the brothers opened a tavern, PBK's (below) in part of the building on Main Street. It later became known as Knebel's Tavern, or Tuff's, when Burwell "Tuff" Knebel took over in 1952. In 1956, it moved to the north side of Pecan Street, later relocating to the south side of the street in 1983. The family-owned tavern was sold in 2008 to the Red Rooster. (Both courtesy of Knebel family.)

On July 20, 1971, a half block of Main Street was destroyed by fire. Nearly 100 volunteers from throughout Central Texas—including Taylor, Granger, Elgin, Round Rock, Georgetown, Austin, Travis County Control, Travis County Precincts 1 and 2, Oak Hill, Leander, Hudson Bend, Pilot Knob, Manor, Hutto, and Jefferson Chemical Company—battled the blaze. Twenty-three fire trucks from 17 units responded to the blaze. Two manufacturing companies were engulfed in flames. A large order of lumber recently delivered to one of the buildings resulted in an estimated loss of $100,000. Water tankers were called in, and farmers hauled water from farm ponds in tanks on trailers behind pickup trucks. Flames and smoke could be seen from Taylor, about 20 miles away. Part of the Pflugerville Mercantile (above) was damaged by the fire; no injuries resulted. (Above, courtesy of Clarence Bohls; below, Treldon Bohls.)

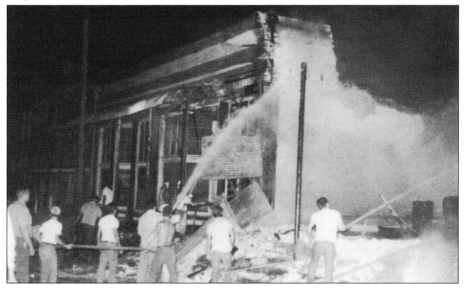

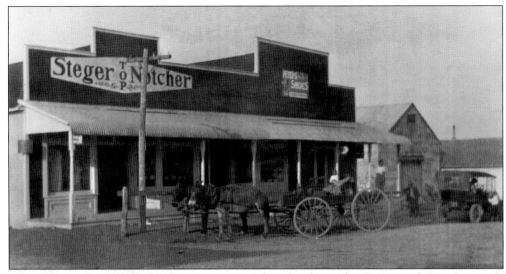

Seen above is Steger Top Notcher, a prominent business located at Pecan and First Streets. It began serving the community in the early 1900s, selling dry goods and groceries. Its advertisement promoted it as "the place to buy to get your money's worth." Below, discussing politics at Steger's are, from left to right, Frances and Fritz Wieland, US congressman Homer Thornberry, and owner John L. (J.L.) Steger. Constable Elzy Blackman frequently joined the conversations as he walked the streets daily, also picking up the mailbag and delivering it to the post office when the train passed through. (Above, courtesy of HHM; below, J.L. Steger family.)

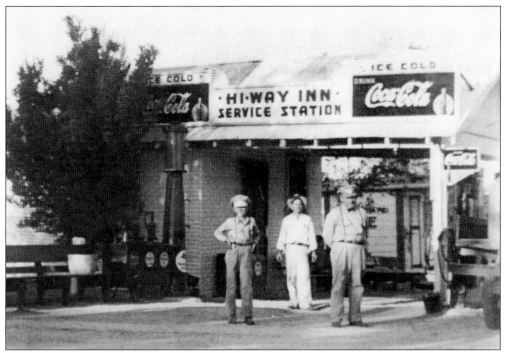

The Hi-Way Inn Service Station at First and Pecan Streets had an icehouse, providing easy access to a necessity. Henry and Estelle Becker opened the station in the early 1940s, operating it until retiring in 1973. Becker had beehives, selling the honey for extra income, and ran a laundry for the CCC camp. Following decades of full service, the location was the site of the town's first convenience store, U-Tote-M, and later Circle K. Above, from left to right are Becker's son Clarence, Texaco distributor Bernie Doerfler, and Henry Becker in front of the station. Below, the Beckers stay warm by the stove inside the station. Their youngest child, Gayle, was instrumental on a national level in the 2000 election of Pres. George W. Bush. (Both courtesy of Elvira Becker.)

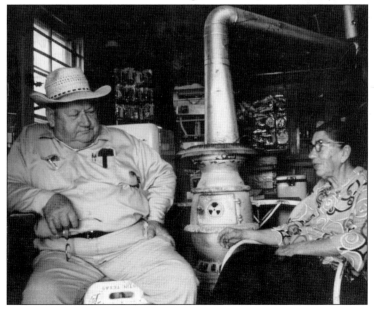

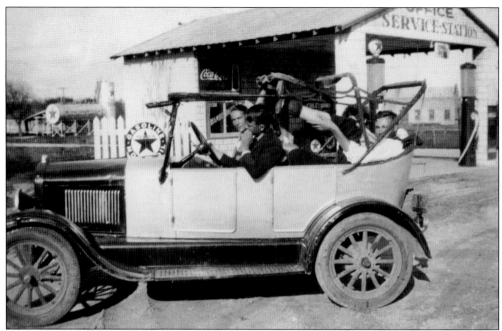

In 1934, these Pflugerville High School senior students gassed up their vehicle at the full-service Bernhardt O. (B.O.) Doerfler Texaco Station. In the background is the Doerfler Texaco distributorship on Railroad Avenue. (Courtesy of Knebel family.)

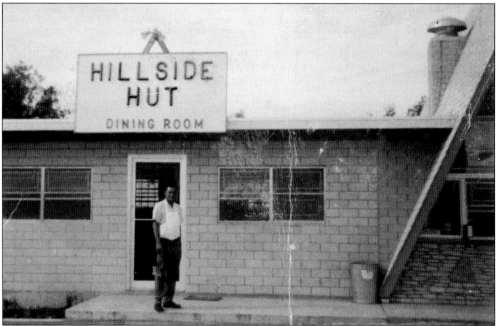

Hillside Hut, with its familiar A-frame, was a popular hamburger and frozen custard stand. Opened in 1967 by Leon (shown here) and Gladys Pfluger, it had two walk-up windows and picnic tables on the east side. Pfluger added a dining room and expanded the menu to include steaks and baked potatoes. Pfluger's daughters—Susan, Jean, and Janet—helped run the business, which closed in 1971. (Courtesy of Gladys Pfluger.)

Four

EDUCATING THE CHILDREN

Early settlers brought with them a strong commitment to education. Lessons were taught at home until the first one-room schoolhouse, with 20 students, opened in 1872 on Henry Lisso's property, located at present-day Wells Branch Parkway and Immanuel Road. One teacher handled instruction for all elementary grades. As the population increased, an area of rural schools were supported by the farming communities of Dessau, Richland, Rowe, Center Point, Gregg, Highland, and Prairie Hill. All of them consolidated into Pflugerville by 1936.

A two-story white brick building was constructed in Pflugerville in 1907 on property donated by George Pfluger. The *Pflugerville Press* reported, "The town that furnishes superior facilities for education of the rising generation is the town that prospers, and its people are happy." In 1921, a larger, two-story redbrick school was built on Pecan Street as a sanctuary of learning. As the community expanded, a few rural school buildings were moved to the site to provide additional space. In the 1940s, Army barracks were added for first- and second-grade classrooms, as well as space for the Future Farmers of America (FFA). During the uneventful and smooth integration of schools in 1965, the Colored School, as it was known when built in 1928, was moved onto the campus for additional classroom space.

High school football games were a favorite attraction of the community over the decades. In the 1930s, games were played on a cow pasture, requiring cow patties and grass burrs to be cleared before each game. Players seldom had shoes or football gear during the Great Depression and war years. Winning traditions were established; the popular *Friday Night Lights* television drama had its beginnings here. *Time* magazine on October 26, 1962, wrote, "To the German-descended citizens of Pflugerville, Texas (population: 400), the most important things in life in approximate order are chores, church, and football."

The transition from rural schools to a district of 23,000 students on 30 campuses continues to challenge leaders to accommodate and provide a rapidly expanding and diverse student population with a world-class education while maintaining the excellent quality, values, and traditions the settlers established.

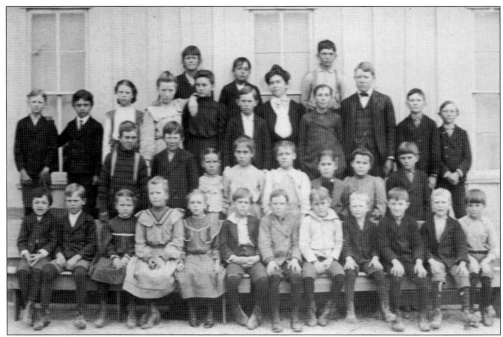

Carrington School, on the Carrington ranch northwest of where the Heritage House Museum is now located, was a one-room school with one teacher for eight grades. John W. Neese taught here in 1903–1904. Otto W. Bohls (above, first row, second from the left) later became a school board president and worked for the Lower Colorado River Authority. The white brick school (below), near Wilbarger and Fourth Streets, was built at a cost of $5,000. Increased enrollment required additional teachers. Prof. B.F. Ebderle of Kerrville was principal, and Temple Harris of Austin was a teacher. Emma Kuhn taught the third and fourth grades from 1907 to 1911 at a salary of $60 a month. A Mothers and Coworkers Club (beginnings of the Parent Teachers Association) was formed in 1913. School supplies consisted of pencils and writing tablets. (Both courtesy of Clarence Bohls.)

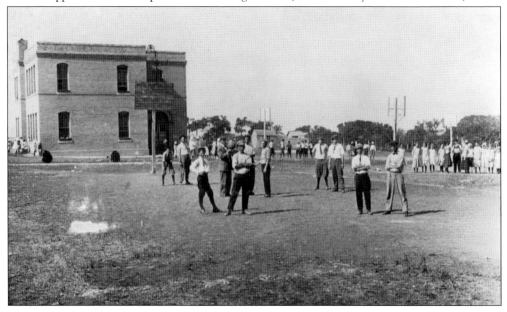

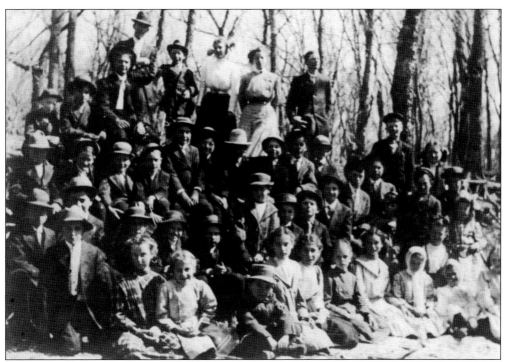

Above, students enjoy a school picnic in 1911, with the boys wearing their fedora hats. The school term extended over seven months for the nine grades taught. Courses in the ninth grade curriculum included physics, geometry, algebra, general history, composition, and civics. Students provided their own way of getting to school and did chores before and after classes. Severe discipline included use of the switch or paddle. At right, the 1911 high school class included graduating seniors of the first commencement exercise, which occurred on April 28, 1911. The graduating students included Minnie Pfluger, Minnie Blacklock, and Berthel Ray; L.C. Smith was the teacher. The first school trophy was earned in 1918. (Both courtesy of Treldon Bohls.)

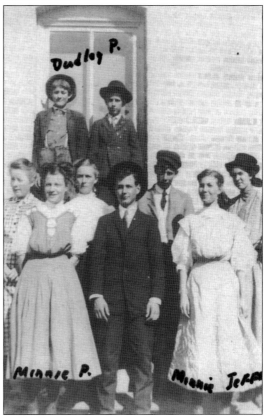

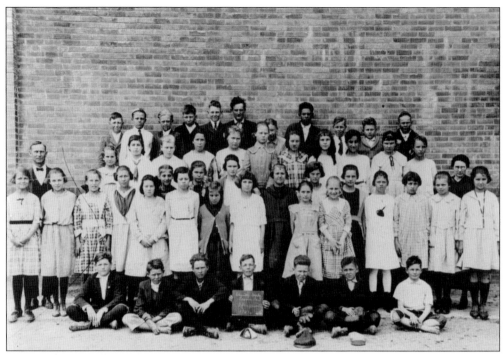

The first class to graduate from the new, 11-grade redbrick school of 171 students in 1922 included Edna Nehring, Edna Pfluger, Helen Ware, Lillian Landua, and Luther Blacklock. The school, which had high academic standards, participated in the Travis County Interscholastic League, including field and literary events. (Courtesy of Herbert Wolff.)

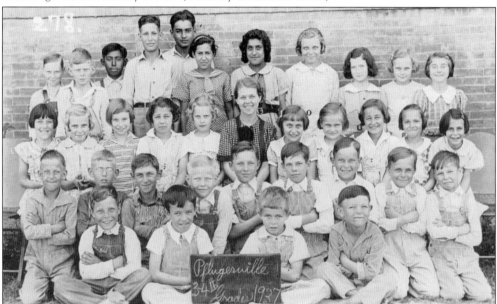

The 1937 third-and-fourth-grade class in Pflugerville School was held on the second floor of the redbrick school. Clarence Bohls, who later became mayor, is pictured in the first row, third from the left. Boys were dressed in overalls and were often barefoot. The teacher was challenged to plan lessons for two grades and meet the diverse needs of each student. (Courtesy Clarence Bohls.)

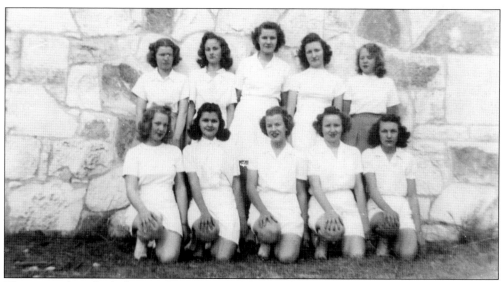

The 1947 girls' volleyball team played in the Pflugerville gym, more commonly known as the Rock Gym. From left to right are (first row) Betty Lois Janke, Marilyn Kuempel, Mildred Fuchs, Waldine Gonzenbach, and Margaret Fuchs; (second row) Nelda Randig, Dora Nell Mehner, Winnie Mae Kuempel, Frieda Becker, and Nellene Kuempel. (Courtesy of Clarence Bohls.)

A simple lunch of homemade jelly on bread sandwiches with seasonal fruit was brought in a tin lunch bucket or satchel in 1895. One of the rural teachers, Thelka, daughter of Fritz and Dorothea Pfluger Ganzert, received her training at the Summer Normal Institute in Austin, passing the state teacher's examination in 1905. (Courtesy of Harriet Hocker family.)

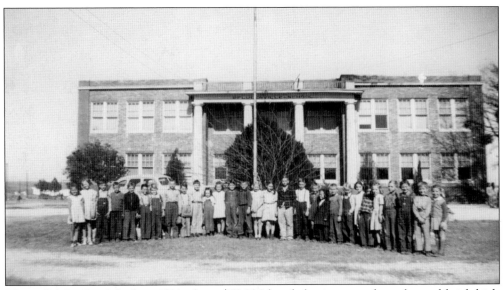

The redbrick school, built in 1921 after a $50,000 bond election, was the only rural brick high school in Texas at the time. Elementary classes were held on the second floor, with two grades in each classroom. These classrooms opened to form a large auditorium and stage. Windows opened for ventilation, and restrooms were located outside. In 1957, it was torn down after being damaged by a tornado. (Courtesy of V. Mott.)

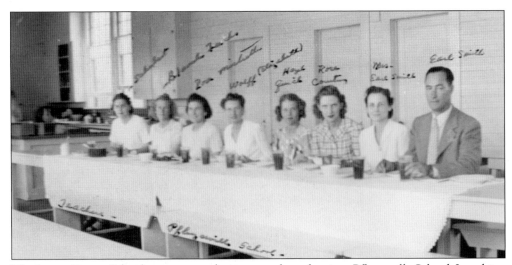

The former Dessau School was converted to serve as the cafeteria at Pflugerville School. Lunching with the school staff is Supt. Earl Smith (right), who served from 1942 to 1948. When the new cafeteria was built in 1955, the building was repurposed to become a homemaking classroom. (Courtesy of Treldon Bohls.)

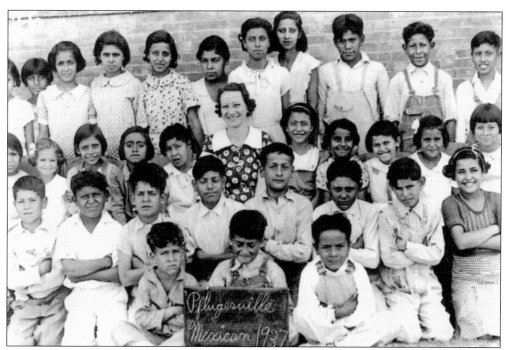

The Mexican School, as it was once known, was built in the 1930s on the Ernest Pfluger farm near the current library. Sulema Riojas attended this school, graduating as the 1952 valedictorian at Pflugerville High School. Mostly Anglo teachers, including Helen Gault, Rose Steger, and ? Wolfe, taught students in the two-room schoolhouse. For lunch, the students walked across the street to Pflugerville School, two blocks away. (Courtesy of HHM.)

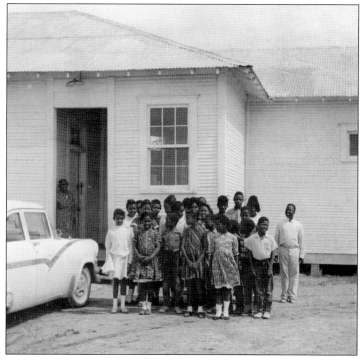

African American children attended the Colored School, as it was known then, near St. Mary Missionary Baptist Church. Two teachers taught 70 students. To complete their secondary education, students were bussed to Hopewell School in Round Rock until integration in 1965. Morning chores had to be completed before the five-mile walk to school, with evening chores waiting when they returned. Early teachers were paid for seven months of classroom construction a year. (Courtesy of Caldwell family.)

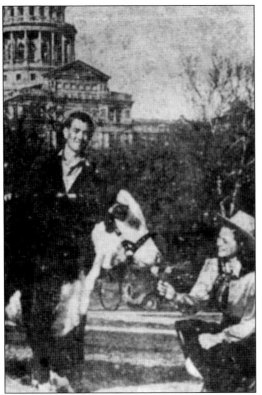

Stock shows, with calf scrambles, pig scrambles, rodeo princesses and queens, and the Bill Hames carnival, were a spring tradition. Raymond Hees (at left) shows his reserve champion steer at the first Travis County Livestock Show in 1940, held near the capitol. Exhibitors washed and groomed their animals before entering the show ring. Showmanship was taught and practiced daily in preparation for the big event. From 1942 to 1946, the show was held at the Municipal Market House, moving in 1949 to the City Coliseum. Noted performers attracted audiences of 2,000 for the nightly events. Below are, from left to right, Future Farmers of America (FFA) Sweetheart Jean Nelson, Lavern Wittenburg, William Wieland, Henry L. (H.L.) Weiss, and Johnny Swenson. In the background are the buildings from Center Point School (band hall), the redbrick school, and Dessau School (homemaking). (At left, courtesy of Joyce Hees Stuewe; below, V. Mott.)

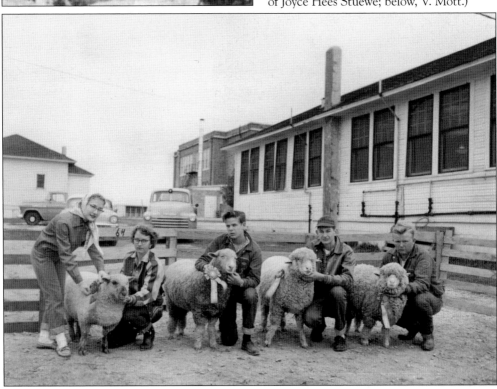

Formal training for young women was provided through the 4-H Club or Future Homemakers of America (FHA). At right, Blanche Fuchs displays her canned vegetables and preserves from the home garden as possible entries in the county fair competition or the Texas State Fair in Dallas. Below, in 1956, Lanier Bohls (left) shows the buyer from Handy Andy grocery store his reserve champion Corriedale lamb. Area champions were awarded show money and college scholarships, which assisted in pursuit of higher education. In 1960, Bohls showed the grand champion barrow hog and in 1961 received the L.J. Luedecke Herdsman Award. As a prominent farmer, he was named Corn Producer of the Year in 1985 and 1986 and was awarded the Agricultural Producer of the Year in 1995. He served on the Travis County Farm Services Agency Committee for 13 years. (Both courtesy of Treldon Bohls.)

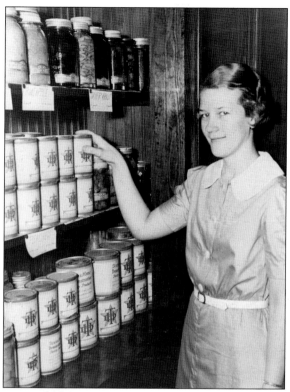

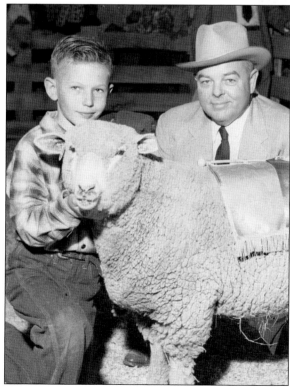

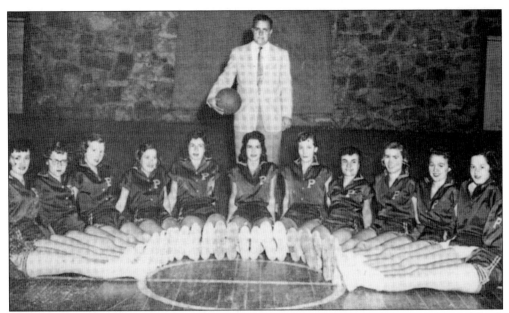

The Rock Gym quickly became an area-wide destination, attracting such teams as Round Rock and Hutto. The girls' volleyball and basketball teams, as well as the boys' teams, were highly competitive. Today, the landmark gym is a noted venue. Above, the 1957 girls' basketball team members, with coach Hub Kuempel, are, from left to right, Bunny Laurence, Carolyn Hartmann, Kay Tyler, Vernagene Hebbe, Claire Saegert, Barbara Jennings, Julia Wuthrich, Shirley Johle, Gloria Pfeil, Gladys Pokrant, and Carolyn Barron. Below, the Panther baseball team included, from left to right, (first row) Ed Volek, Atlan Pfluger, Stanley Pfeil, Robert Weiss, Larry Pfluger, and William Wieland; (second row) coach Charles Kuempel, Charles Mott, Glenn Weiss, Oscar Israel, Edward Pokorney, Jefferson B. (J.B.) Marshall, and John Israel. (Above, courtesy of V. Mott; below, HHM.)

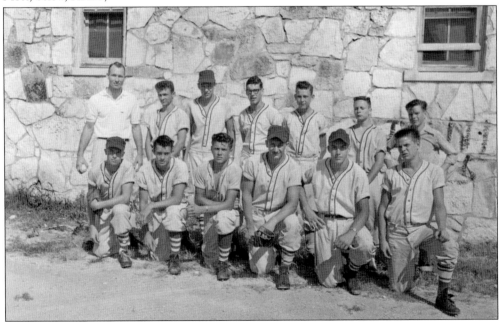

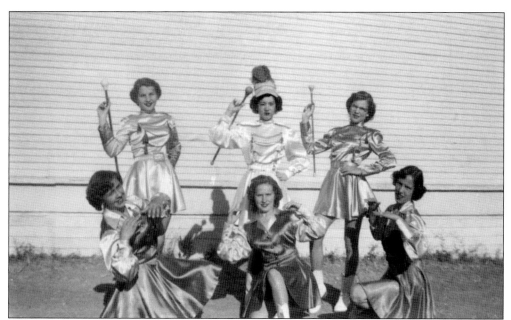

Above, the 1953 cheerleaders in their blue and gold satin uniforms are, from left to right, Joyce Bohls, Betty Joyce Wieland, and Peggy Beckham; the twirlers are, from left to right, Lois Klattenhoff, Mary Jo Fuchs, and Doris Schoen. Below, the 1955 band, under the direction of E.W. Tampke, marches in their new uniforms. The band grew from a few dozen to more than 400 members, winning numerous state and national awards. In the background are the elevated press box and the homesteads of Pfluger brothers Fritz (center) and Albert (right). The lighted field was a welcomed addition. Even though students had minimal practice time for extracurricular activities due to required chores before and after school, they performed, continued the expected winning traditions, and supported the football team that from 1948 to 1983 had a game record of 242–124–2. (Both courtesy of V. Mott.)

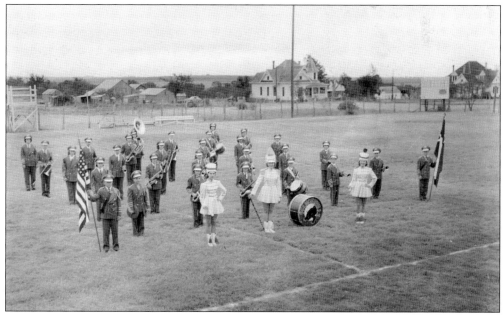

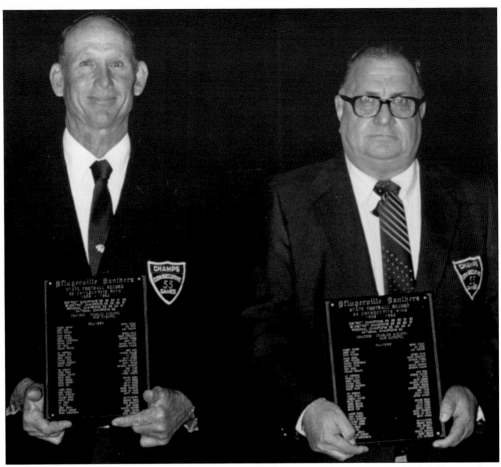

Charles W. Kuempel (left), head coach for 19 years, and cousin and assistant coach Hub Kuempel are holding plaques and wearing honorary jackets, reflecting 55 consecutive football games won. From 1958 to 1962, the teams amassed 2,354 points to their opponents 251, with 30 shutouts. This incredible feat set a national record. Both Charles, a distinguished alumnus of Texas Lutheran University, and Hub, a graduate of the University of Texas at Austin, returned to their high school alma mater as teachers and coaches. Kuempel Stadium at Pflugerville High School is named in their honor. Below, a Texas-sized billboard was erected on the main highway saluting the home of the National Schoolboy Football champions. (Above, courtesy of Melanie Samuelson; below, V. Mott.)

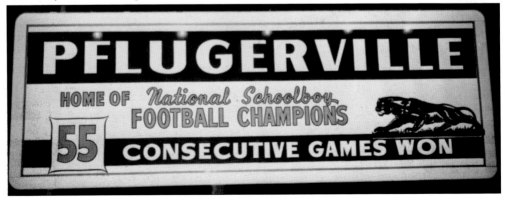

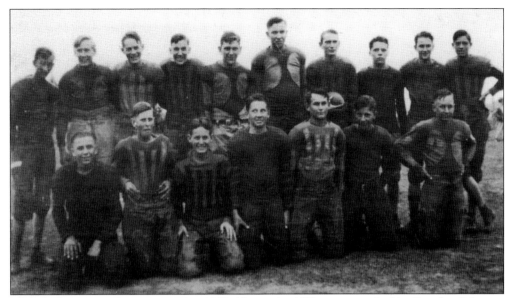

A football team was first organized in 1927. Above, the 1933 team, coached by Gunther Schwarz, won the first 11-man championship. Their record was 10–0, including a 101–0 record victory over Manor. The 1938 team beat Liberty Hill, Bertram, and Leander. World War II forced the discontinuation of football in 1942; it resumed in 1947 as six-man football. Championship seasons returned, with the 1952 team scoring 98 points against Blanco and 95 against Buda during an 8-1 season. A string of successes followed in 1953 (9-1), 1954 (9-1), and 1955 (8-2). In the absence of fancy equipment used to train athletes today, players on these teams got muscle-building exercise by doing farm chores and hay hauling. Below, the 1961 team had players who never experienced a loss. Both the 1970 and the 2007 teams were state finalists. (Above, courtesy of Knebel family; below, V. Mott.)

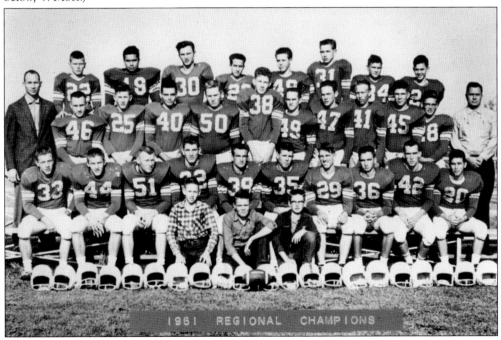

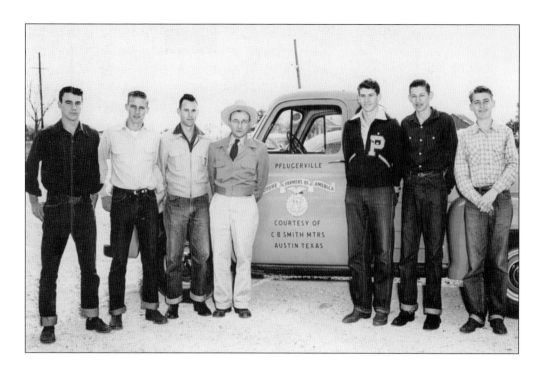

Above, the 1955 FFA officers are, from left to right, Sid Tetens, Homer Wieland, Milton Koch, teacher George Simon, Armin Wendland, H.L. Weiss, and Tommy Pfluger. The truck was provided by a local car dealer. Below is the 1956 annual FFA and FHA coronation in the school auditorium. FFA (teaching welding, carpentry, and mechanics) and FHA (teaching sewing, cooking, and home decor) were required courses for each student. From left to right are Wilbert Becker, Shirley Johle, Tommy Pfluger, Lavern Wittenburg, Bobby Pfluger, Julia Wuthrich, Eddie Reeves, Claire Saegert, H.L. Weiss, D'Ann Watson (sweetheart), Roland Wieland, Gloria Pfeil, Gladys Pokrant, Robert Weiss (beau), Jeri Pokorny, Johnny Pokorny, Barbara Jennings, Charles Mueller, Bunny Laurence, and Milbert Pokorny. (Both courtesy of V. Mott.)

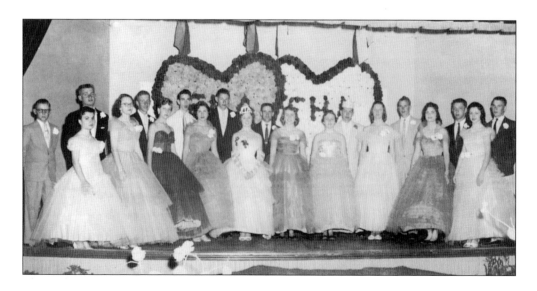

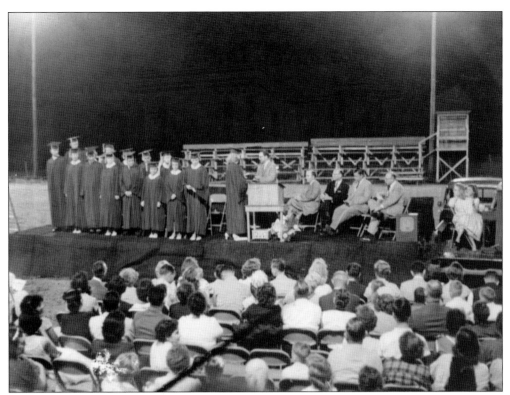

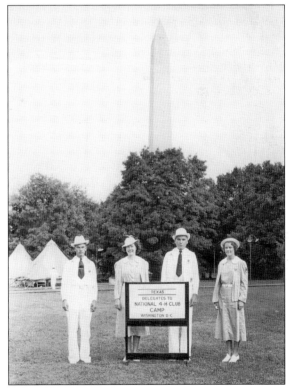

Above, after the auditorium in the high school was destroyed by the 1957 tornado, graduation was held on the football field. The stage was formed by several flatbed trailers covered with artificial grass from the local funeral home, and the piano was loaded onto a pickup truck to provide the pomp and circumstance. Supt. Ray Nelson is to the right of the podium. At right, Pflugerville's Blanche Bohls (far right) represented Texas at the 11th national 4-H Conference in Washington, DC. Four students were selected from each state to participate, and they camped on the banks of the Potomac River. Organized over a century ago, 4-H (heart, head, hands, and health) continues to impact young people locally and nationally, providing opportunities for students while promoting citizenship, character, leadership, and education. (Above, courtesy of V. Mott; at right, Treldon Bohls.)

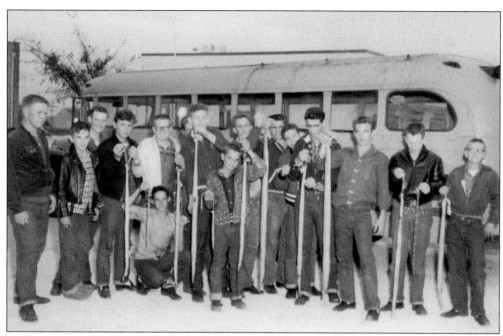

Above, FFA boys, on a field trip to the A.G. Braun Hereford Ranch in Georgetown to study show calves, uncovered a den of rattlesnakes when they overturned stones as they hiked the rocky pasture. Because of the cool weather, the snakes were moving slowly, allowing the boys to kill the creatures with sticks and stones. Texas historian and author J. Frank Dobie, in his book *Rattlesnakes*, documents rattlers on the Albert Pfluger ranch. The bus, parked near the Lively Café, also transported students to Austin for mass polio inoculations in the early 1950s. Below, 1950s school board trustees use push mowers to beautify the frontage on Pecan Street. From left to right are Lawrence Pfluger, Edward Gonzenbach, Eddie Imken, Carl Wieland, Elmo Wittenburg, and Eugene Hebbe. The new domed gym is on the right; Rock Gym is in the background. (Both courtesy of V. Mott.)

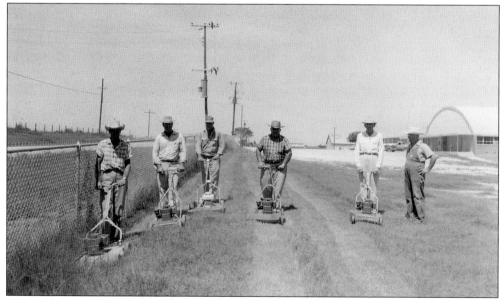

Five

LIVING OUR FAITH

Settlers were limited in what they could pack for the voyages across the Atlantic. Of utmost importance was the cherished German family Bible. In 1852–1853, circuit rider Pastor J.M. Kugel provided divine services in the area. The first religious gathering was held in the schoolhouse on the Henry Lisso farm on Windscott Creek, with 40 souls attending. Several Methodist pastors endeavoring to bring about an organization were unsuccessful. Fear existed that to adopt a church constitution would deprive settlers their freedom. Each phase of church development had challenges. The first church in Pflugerville, Immanuel Evangelical Lutheran Church, was founded on May 31, 1874. Prior to World War I, sermons were conducted in German.

Organized in 1906, the first Baptist church consolidated with the Walnut Creek Baptist Church in Austin in 1937. The wood from the Pflugerville Baptist Church was used to build the Walnut Creek parsonage. In 1909, the Reverend Squire Roberts held church services under a brush arbor on the Fritz Pfluger farm. Within a few months, services moved to the school. In January 1910, under his leadership, St. Mary Missionary Baptist Church was organized. The first church, built in 1911, was destroyed by storms and later rebuilt.

The first Catholic Mass was held in Pflugerville in 1919. In 1926, the church was organized, with services being held in homes. It was a mission of Our Lady of Guadalupe Catholic Church in Austin until 1932, when Saint Elizabeth of Hungary Catholic Church was dedicated. Santa Maria Cemetery was established in 1924; the first burial was of Camilo Mercado. Early families who came here to escape the Mexican Revolution had no burial insurance; thus, the Sociedad Funeraria de Agricultores Mariano Escobedo chapter was organized to assist. In 2003, it was designated a historic Texas cemetery. In 1923, the Methodist church was built for $2,500.

Faithful leaders have provided guidance and support through calamities and celebrations over the past century. Today, there are more than 50 houses of worship of all denominations, in which the gifts and talents of members carry out their mission and minister to the needs of the community.

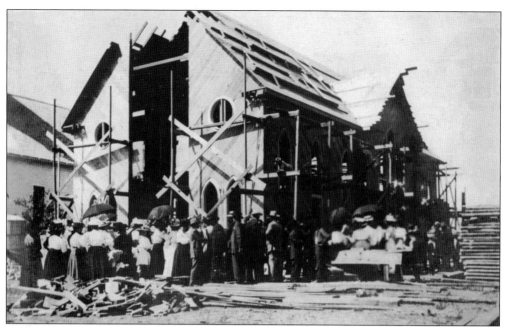

Organized in 1874, Immanuel Lutheran Church built the original wood structure (above) in 1875 on five acres donated by William and Catherine Pfluger Bohls. The building measured 26 feet wide, 44 feet long, and had a 16-foot-high steeple, all at a construction cost of $350. In 1910, a new redbrick structure (below) costing $10,300 was dedicated. The dedication was postponed a month due to a severe blizzard. Fire destroyed the building in 1928. The present beautiful, stately brick sanctuary was completed in 1929 for $43,000 and has seating for 650. The cemetery, located adjacent to the church at 500 Immanuel Road, reflects the names of many of the settling families. There have been more than 1,042 burials, with the earliest recorded birth in 1778 and the earliest death in 1872. (Both courtesy of Melrose Zimmerman.)

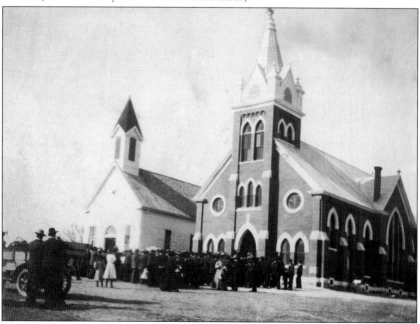

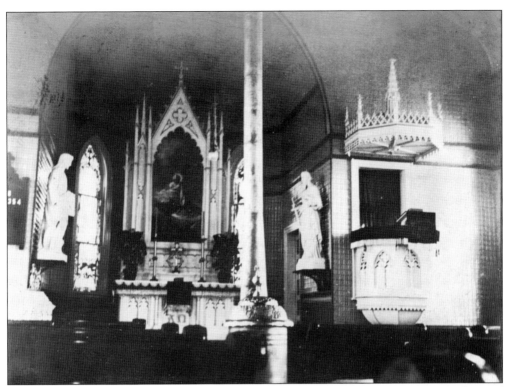

The official record book of the Lutheran church continued to use German headings and titles until 1935, when the congregation resolved to exclusively use the English language. Not until 1940 did women become voting members. Members paid annual dues according to a class system. Above is the ornate interior of the 1910 church. The baptismal font, altar cross, and candles, saved from the 1928 fire, adorn the present sanctuary. Donations provided for the stained-glass windows, altar, Reuter organ, hymn board, light fixtures, and pews. Below, Pastor Gottlieb Stricker is with the 1913 confirmation class in front of the parsonage. Following prescribed instruction, the special confirmation day arrived either on Pentecost, Reformation, or Palm Sunday. A cherished gift on the occasion was a personalized engraved leather Bible. (Above, courtesy of Melrose Zimmerman; below, Treldon Bohls.)

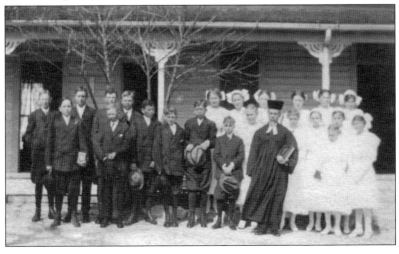

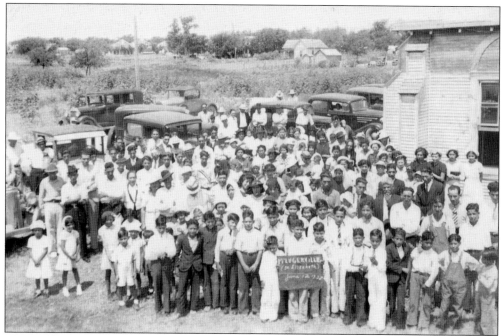

The first Catholic Mass in Pflugerville was conducted in 1919. The church was a mission of Our Lady of Guadalupe Catholic Church in Austin until 1932, when Saint Elizabeth of Hungary Catholic Church, above, was constructed on property purchased from Estanislao and Anita Cantu for the price of taxes owed. In 1977, the church moved from the corner of Railroad Avenue and Wilbarger Street to its present location on Pflugerville Parkway. Many of the parishioners were buried in Santa Maria Cemetery. Below is the 1930 congregation of the Methodist church, built across from the water tower in 1923 for $2,500. In 1966, the congregation disbanded, and the church building was destroyed by fire in 1971. Today, First United Methodist Church is located on Pecan Street, near the gin. (Above, courtesy of HHM; below, Clifford Ward.)

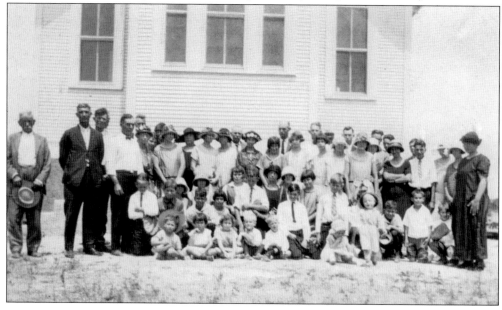

Under the leadership of Rev. Squire Roberts, St. Mary Baptist Missionary Church was formed in 1910. Rev. A.K. Black negotiated the purchase of land, and a new church sanctuary was completed in 1916. Faithful and dedicated leaders have served over the decades, including Rev. Cecil H. Young (18 years) and Pastor Richard Coaxum (over 19 years). To the right, the 1960 congregation gathers on the steps of the old church. A new 11,000-square-foot, 500-seat sanctuary was completed in 2001. Below, the church choir not only enhances regular worship services but performs majestically for community events, with traditional anthems and spirituals. Singing in the choir is a rewarding and inspirational endeavor, glorifying and praising God through song. Recently celebrating their 100th anniversary, the church has a solid foundation in this growing and diverse community. (Both courtesy of the Caldwell family.)

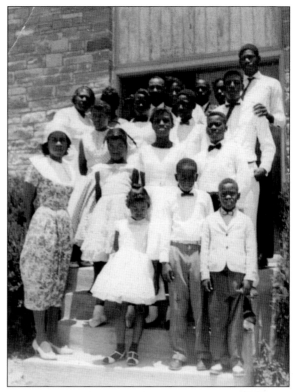

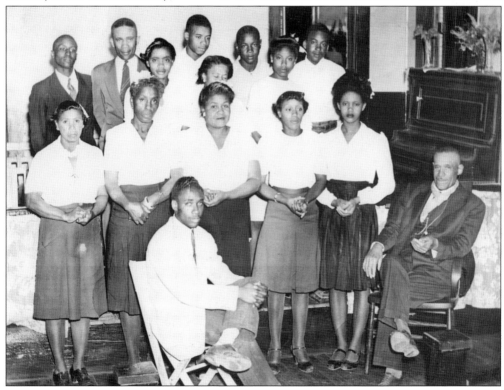

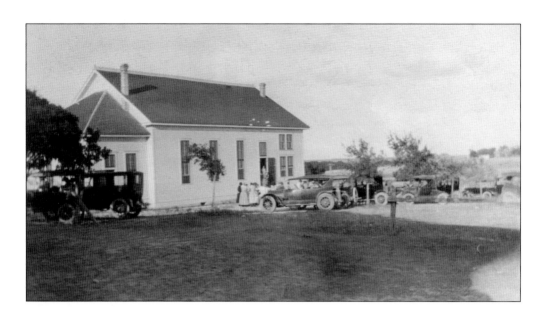

The Luther League of Immanuel Lutheran Church was organized in 1913 with 34 members. The Luther League Auditorium was built in 1916, complete with a stage, balcony, kitchen, and seating on an incline. It was the first Lutheran Parish Hall in Texas, and it hosted the Texas District Luther League Convention in 1919. The Texas District of the American Lutheran Church was hosted here four times. The stage was the setting for annual play productions. The youth of this community from generation to generation are engaged in state and national gatherings, growing spiritually, and rendering service to others. Regular events included weekly Sunday school, monthly meetings of the Tabea Verein (below), and annual mission festivals. The customary attire for women during the 1920s included a hat and long dress. Open windows provided cross-ventilation for cooling. (Both courtesy of Waldemar Pfluger family.)

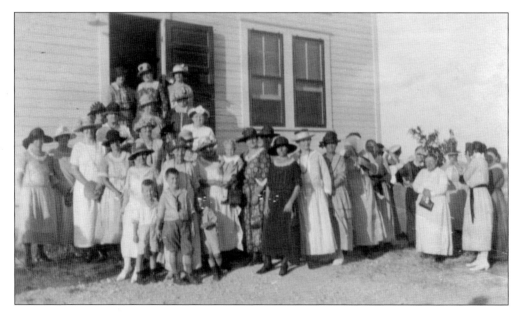

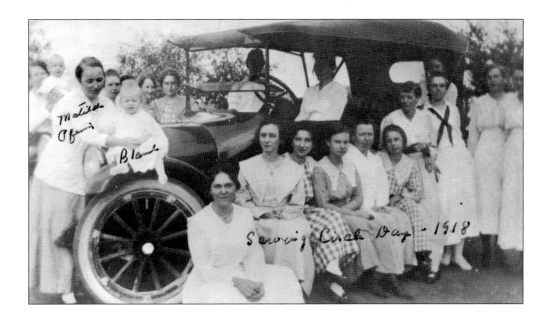

The Immanuel Sewing Circle (above) organized in 1912 and met monthly to embroider, cross-stitch, quilt, and crochet. Proceeds from their sales were used to purchase pianos and furnishings for the church. Dues were a nickel a month, with the first contribution pledged to an orphanage. The motto of the group was, "coming together was a beginning, keeping together was progress, and staying together was success." With 22 ladies signing the constitution, the Immanuel Tabea Verein was organized in 1915. The Calendar Supper (below) was a special event with ladies dressed in unique attire for each month of the year. In the background, the Conrad Pfluger homestead is east of the church, with the fence bordering the Old Austin-Hutto Road, later becoming Dessau Road and presently named Immanuel Road. (Both courtesy of Treldon Bohls.)

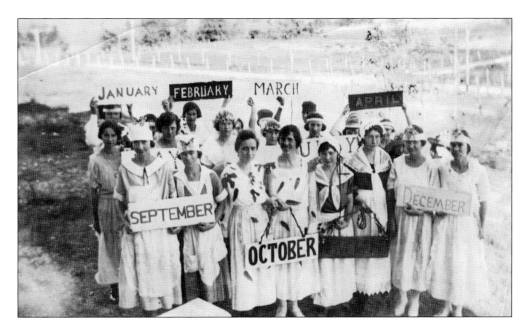

The Tabea Verein, organized in 1915 with 22 members, grew to nearly 100 members by 1960. When the German language was forbidden in the United States during the war, the group returned to an earlier name, Ladies Aid (active 1887–1894). In 1969, the name changed to American Lutheran Church Women (ALCW). Through the decades, their countless fund-raisers and worthy projects have benefitted the community. The ladies, descendants of early settlers, spent their entire life in this area. Black dresses were commonly worn in public. Above, surviving charter members in 1956 are, seated from left to right, Lillie Pfluger, Lena Timmerman, Anna Sophia Pfluger, Rosa Fuchs, and Helene Pfluger. The Immanuel Brotherhood was organized in 1941 with 17 charter members. The men followed the four-fold plan of devotion, education, service, and fellowship. Below, they gathered at their summer event in the Fritz Pfluger Grove, now Pfluger Park. Today, the men participate in the Men's Breakfast and volunteer for Habitat for Humanity projects. (Above, courtesy of V. Mott; below, Treldon Bohls.)

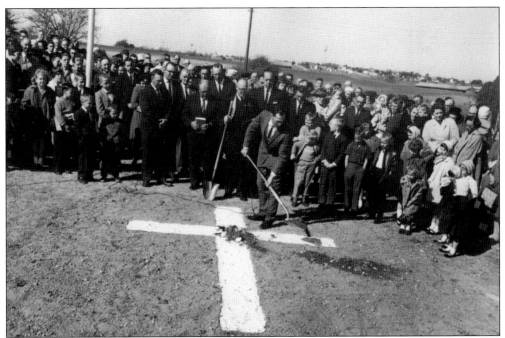

Above, the Immanuel Lutheran Church congregation celebrates the 1963 ground-breaking for a $100,000 building program, including a new parsonage and education facility. In the center are, from left to right, church council president Carl Wieland (with Bible), Pastor Wilson Hill, and Lamar Weiss. In the background is the village of Pflugerville. Due to visionary leaders and active congregants, the campus has expanded to 14 acres, with 50,000 square feet in facilities. Below, on stage in the new building is the Jesus Christ and Company youth group, who sang praises throughout central Texas. In the third row are directors V. Mott (far left) and Annyce Bohls (far right). All continue serving in their communities in countless ways. Common daily prayers included "Come Lord Jesus, Be Our Guest," and "Now I Lay Me Down to Sleep." (Both courtesy of V. Mott.)

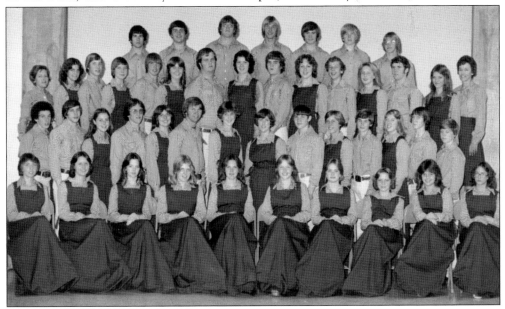

One acre near the homestead was donated by Mrs. (Anna Christina) Henry Pfluger Sr. for a cemetery. In this historical cemetery are 18 graves (ranging from 1880 to 1917), including Henry, at left, his wife, and some of their children. Below is the burial at Immanuel Cemetery of Anna Elizabeth Pfluger. The Ladies Aid organized in 1887 for the purpose of caring for the cemetery. Inscriptions on tombstones represent early pioneers and founding families whose efforts formed the foundation of organizations, businesses, schools, and strong values. Uniquely designed tombstones reflect special Bible verses. While infant mortality was high and epidemics such as pneumonia, flu, smallpox, scarlet fever, and diphtheria took their toll, many folks also experienced longevity, as evidenced by the many centenarians. Church cemeteries are permanent sites that remain intact long after other remnants of a community disappear. (Both courtesy of V. Mott.)

Six

SHARING GOOD TIMES

Gathering together has been a vital ingredient of life for the residents of the Pflugerville area since the early settlers arrived. Families spent long days working in the fields and enjoyed the opportunity to gather with family and friends. Picnics by Gilleland Creek and family get-togethers for birthdays and anniversaries provided a time for relaxation and catching up on news with relatives and neighbors. School activities included sports such as football, basketball, and volleyball. Football games offered the entire community a reason to assemble every Friday night to support their students.

On Saturdays, families would congregate in downtown Pflugerville to enjoy ice cream at the local confectionery, watch a movie at the outside Sky Dome, attend a political rally, or watch the circus train travel through town.

Fundraisers were well attended for the volunteer firefighters, churches, schools, and numerous civic organizations. From these alliances eventually developed the incorporation of the city government, the establishment of a parks system (including more than 30 miles of hiking and biking trails, over 1,100 acres of park land, and numerous sports fields), the fire department, the justice department, and the library.

The first German Day celebration was held on Sunday, May 29, 1910, with a special train consisting of four cars bringing the Austin Saengerrunde visitors. Also, in 1910, another special train came from Austin for a political rally that attracted about 3,500 folks, with more than 12,500 cups of coffee served to the crowd.

The Schüetzen und Kegel Verein promoted social and cultural events such as shooting contests, bowling, May Fetes, and dances while also hosting an annual fair with agricultural, livestock, needlework, and baked and canned foods exhibits. The band played music throughout the day and for the grand ball at night.

Home Demonstration Clubs provided education, teaching people how to make corn shuck mattresses and, later, cotton mattresses. Women learned to sew comforters using goose down and feathers. The clubs also offered instruction in canning and other essential living skills as well as home decor.

Throughout the ages, there has been a sense of community, with residents interacting joyfully and sincerely sharing a common interest in a common location.

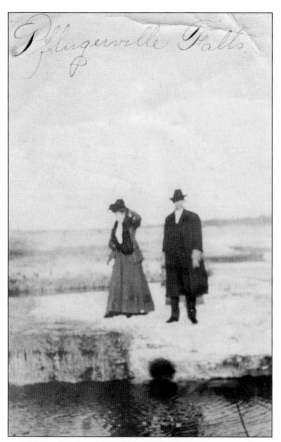

Gilleland Creek, which traverses the town, was a main water source for the business community and was used frequently for recreation. It was a place to learn how to swim in the crystal-clear waters, to have relaxing outings, and to picnic under the huge canopy of shade trees. To the left, a couple enjoys a stroll by Pflugerville Falls, where the creek was dammed to create Katy Lake. Below, family reunions, church gatherings, and children's parties were held during the hot summer months in the Fritz Pfluger Grove. (At left, courtesy of Clarence Bohls; below, Gladys Pfluger.)

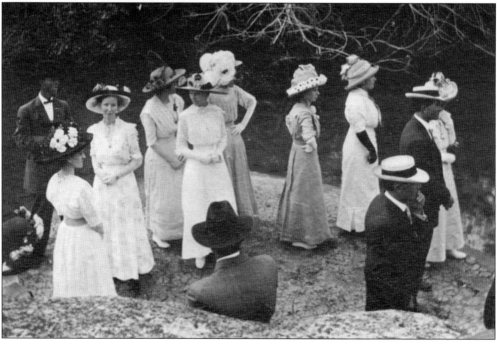

Gilleland Creek, with headwaters in the Edwards Plateau, contained a large rock. At right, it was an ideal location for Max (left) and Alvina Kuempel to sit in the creek and ponder life events with Christian Klattenhoff (right). The creek was also the site of baptisms for the Baptist church. Folks of all ages still enjoy walking the many hiking and biking trails that follow the creek through the city. The creek was also a delight to young fishermen. Below, Hub Kuempel is fishing at the early age of 15 months. This photograph, taken by his uncle Herman H. (H.H.) Pfluger, won second place in a Master Photo Finishers of America Contest in 1930. (At right, courtesy of Kuempel family; below, Melanie Samuelson.)

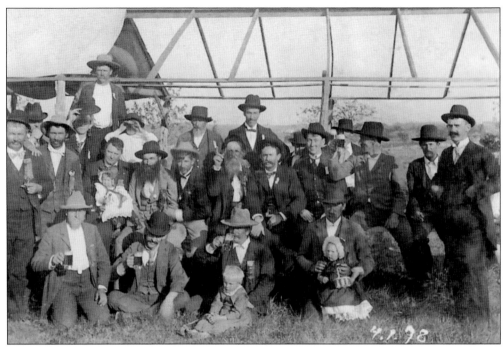

The Schüetzen und Kegel Verein of Travis County organized in 1891 with 25 men of German descent as its charter members. Its purpose was to uphold the German culture, provide social entertainment, and offer neighborly assistance. The hall was built on six acres bought from George Pfluger for $210. A bowling alley was added in 1900. An exhibition of produce and two festivals were held each year, including the May Fete, which had a maypole and crowning of a queen. The old hall (pictured above in 1898) was torn down; the new Pfluger Hall was dedicated on the site in 1986. The new hall is used for community events, including the annual Pfluger family reunion, which began in 1934. In 1910 (below), ladies, dressed in their best, prepare to travel by horse and buggy. (Above, courtesy of Herbert Wolff; below, Clarence Bohls.)

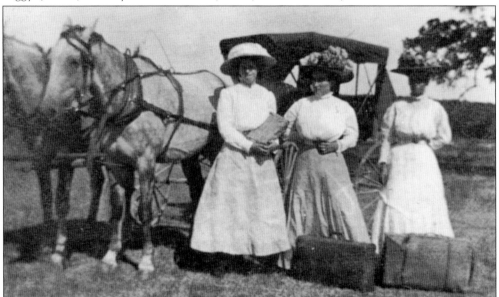

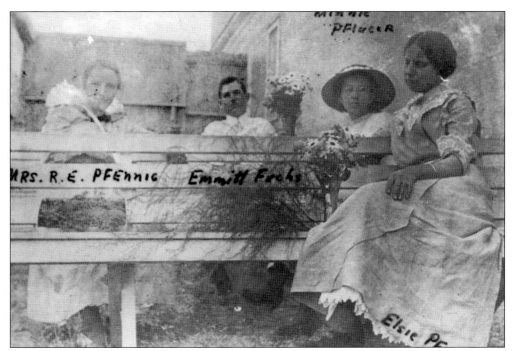

H.H. Pfluger, a cotton buyer, corn breeder, and owner of the Sky Dome Theatre downtown, between the Steger store and Leppin's warehouse, had the first electric system showing movies projected on the side of a building. Patrons of all ages were fascinated. Above, being entertained in the early 1900s are, from left to right, Mrs. Rudolph E. (Matilda) Pfennig, Emmitt Fuchs, Minnie Pfluger, and Elsie Pfennig. A movie cost a nickel, as did popcorn. Families enjoyed camping during the hot summer months. During the early 1900s, Emil Bohls loaded the family truck, below, with gear for a camping trip. Blankets or wagon covers were stretched from the truck to a tree to create a shelter. (Above, courtesy of Treldon Bohls; below, James Bohls.)

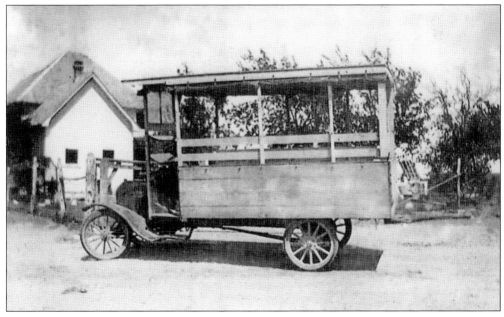

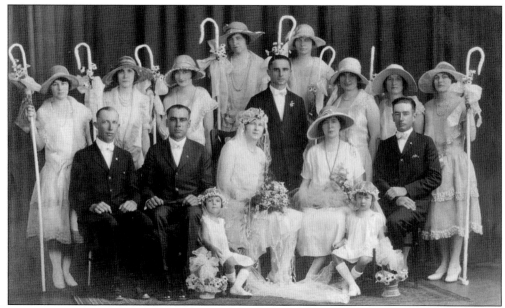

Wedding receptions were held in the home of the bride's parents. Handwritten invitations were delivered by a close relative on horseback. As an acceptance, the addressee would pin a lengthy ribbon on the messenger. By the time the mission was fulfilled, the deliverer resembled a flying colored bird, as everyone in the community would be invited. The bride's wagon or carriage was then decorated with these ribbons. A son, at age 16, received a horse and buggy and when he married and gifted a team of mules, harnesses, and farming implements. A daughter received furniture, linens, and several cows. A gift of gas-ration coupons allowed a brief honeymoon during World War II. Above, Edward and Agnes Fuchs Rogge married on July 10, 1926; below, Herman and Olga Weiss Pfluger married in 1901. (Above, courtesy of Waldemar Pfluger family; below, Gladys Pfluger.)

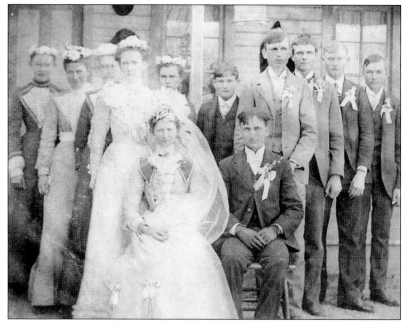

Above, in a 1924 wedding are, from left to right, Christian Klattenhoff, Georgia Kuempel Nelle, Katie Klattenhoff, Armin Pfennig, Max Kuempel (groom), Alvina Klattenhoff (bride), Selma Kuempel, Alice Mahlow Bittner, and Carl J. "Fish" Kuempel. Below, attendees at the 1944 bridal shower for Blanche Fuchs, bride of Chester Bohls, are assembled under a chinaberry tree. A tradition for newlywed couples was a chivaree by friends and family. Quietly after dusk, participants, carrying iron sweeps and an iron rod, surrounded the couple's home. On cue, they initiated an alarmingly loud clanging to startle the couple. When the couple came to the door and turned on the lights, a celebration began with gifts of necessity brought to furnish the couple's home and fill the pantry. (Above, courtesy of Kuempel family; below, Treldon Bohls.)

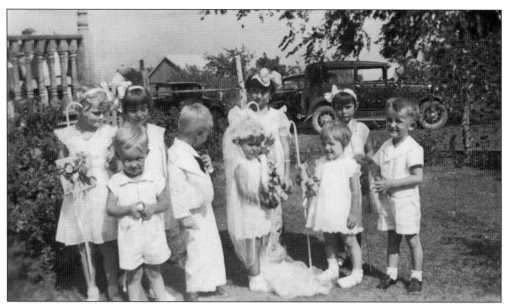

Children played important roles in celebrations. Carl Lisso's grandchildren are dressed for festivities. The unpainted house and barn in the background depict a typical farmstead. (Courtesy of Knebel family.)

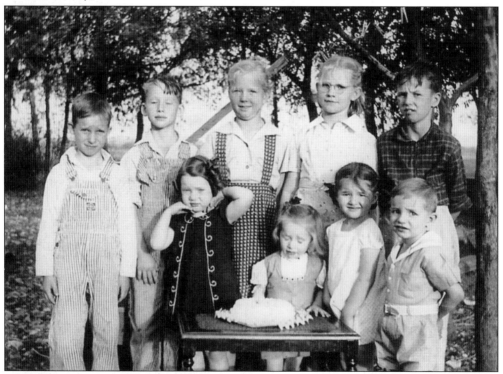

Families congregated to celebrate birthdays. Attending this celebration are, from left to right, (first row) Mary Jo Fuchs, Ann Kuempel, Pat Kuempel, and Earl Klattenhoff; (second row) Theophil C. (T.C.) Pfennig, Charles Kuempel, Nellene Kuempel, Winnie Mae Kuempel, and Max Kuempel. The children watch as the birthday girl eyes her special cake. (Courtesy of Kuempel family.)

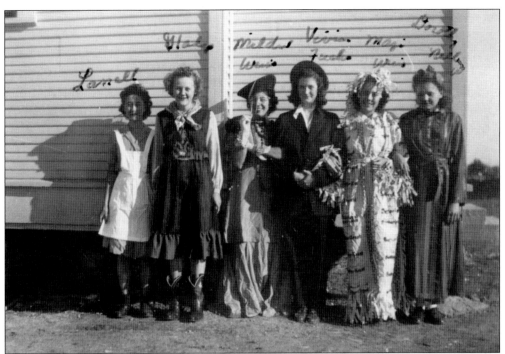

Pflugerville schoolchildren, standing beside the homemaking building, are dressed in costumes for the Halloween program around 1940. From left to right are LaNelle Weiss (cook), Gladys Pfluger (pistol-packing mama), Mildred Weiss, Vivian Fuchs, Margie Weiss (bread wrapper), and Dorothy Wieruscheske. Activities at the Halloween program included bobbing for apples, pumpkin carving, and homemade candies. (Courtesy of Treldon Bohls.)

On Christmas Eve, families attended church services. Children would recite scripture in front of the congregation and again at home before opening gifts. Gifts were usually practical, such as clothing, fruit, and maybe a stick of candy. Trees were cut on the farm, brought in on Christmas Eve, and decorated with homemade ornaments. John and Tommy Pfluger are seen here as they enjoy their toys under the tree. (Courtesy of Waldemar Pfluger family.)

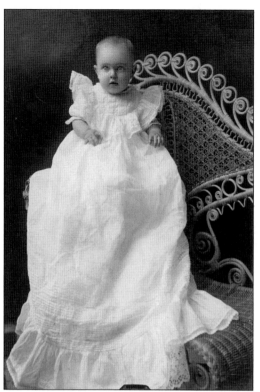

Children were baptized in the family's local church. Lorine Kuhn (who later married Waldemar Pfluger), daughter of Dr. and Mrs. Fritz (Ida) Kuhn, is dressed in this special christening gown made with intricate stitches. Following the christening, the family would gather to celebrate the occasion. Dr. Kuhn was the town physician, delivering many of the babies in the area. (Courtesy of Waldemar Pfluger family.)

Sunday afternoon brought a visit to the William Pfluger home by Pastor William Flachmeier, his wife Emilie, and children, Willie, Irene, Raymond, Hildegard, and Hugo. Flachmeier served as pastor of Immanuel Lutheran Church from 1899 to 1908. Under the pastor's leadership, a choir of 40 members was organized. Increased church membership necessitated a need for a larger sanctuary. (Courtesy of Melrose Zimmerman.)

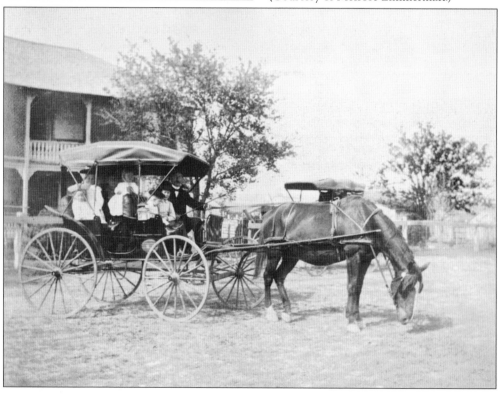

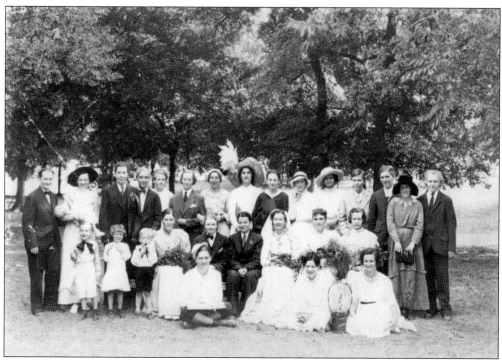

Fundraisers were frequently held to raise funds for groups such as the Parent Teachers Association, churches, and the volunteer fire department. Saturday morning bake sales and car washes were held by teens. One popular activity that attracted crowds was performing a "manless" (above, at the Pfluger family reunion) or "womanless" (below, on the Pflugerville High School football field) weddings. The various roles for a wedding were played by all of the same gender. Sales of tickets, food, and sweets benefitted the school or community. Variety shows, with spectacular local talent, and skits that displayed a sense of humor blended with music to offer entertainment. (Both, courtesy of HHM.)

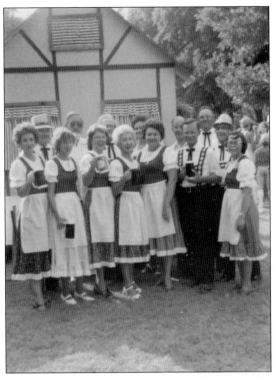

In 1976, the City of Pflugerville formed a committee to organize a community activity in celebration of the United States Bicentennial. Deutschen Pfest became an annual event, now drawing more than 20,000 people from around the area for the three-day festival. Local groups decorate floats and schoolchildren, politicians, churches, organizations, and businesses parade down Main Street. Pfluger Park is the site of musical performers, vendors of foods and crafts, and carnival rides. The Deutsche Volk Sangers performed German folk songs and rode on a uniquely designed float. Their prize-winning floats, including the 1980 "Hofbrauhaus" at left, received accolades in the Austin Aquafest and the New Braunfels Wurstfest. Below, in 1976, Herbert Bohls, his wife, Verline, and daughter Kay drive a wooden buckboard with a milking cow walking along behind, representing local farmers. (At left, courtesy of Clarence Bohls; below, Verline Bohls.)

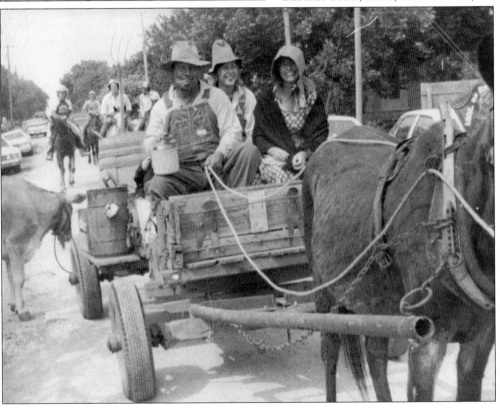

Square dancing has been a favorite pastime for many couples in Pflugerville. To the right, Verline and Herbert Bohls perform a square dance during the 1981 Deutschen Pfest. Other cultural dances include the waltz, polka, *schottische*, *herrschmidt*, cotton-eyed Joe, Paul Jones, jitterbug, and the Texas two-step. The *wurstirito* (sausage wrap) was sold by the German Club. Below, Leon Jaworski, a noted Houston lawyer, was the grand marshal in the Deutschen Pfest Parade. Jaworski lived in the Richland community as a young lad, where his father was a minister. He served as a war crimes prosecutor in Germany following World War II and was appointed as a special prosecutor in the Watergate investigation in Washington, DC, during the Richard Nixon presidency. (At right, courtesy of Verline Bohls; below, Knebel family.)

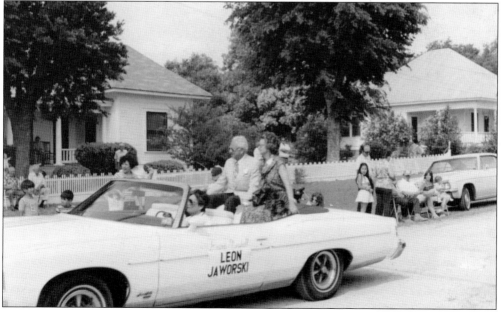

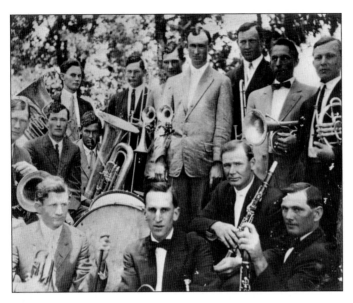

The Pflugerville Band practiced once a week in the early 1920s for performances at May Fetes, political events, and end-of-school concerts. From left to right are (first row) director ? Honeycutt, Edgar Pfluger, Fred Neuenschwander, and Willie Weiss; (second row) Ewald Weiss, Edgar Weiss, and John Banner; (third row) August Weiss, Oscar Banner, Henry Weiss, General Mills, August Mills, Charlie Wieruscheske, and Charlie Weise. (Courtesy of Lamar Weiss.)

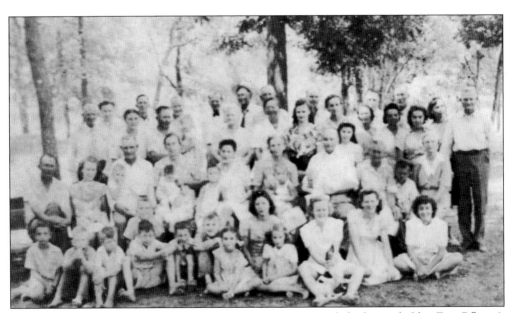

Annual family reunions were traditional summer events, many of which were held in Fritz Pfluger's Grove. Mutton was barbequed by the men, with traditional dishes and desserts prepared by the ladies. Afternoon intergenerational activities included folk singing, baseball games, washers and horseshoe pitching, dominoes, and 42, along with recognition of the oldest and youngest attendees and the greatest distance traveled. Pictured is the 1946 Weiss family reunion. (Courtesy of Lamar Weiss.)

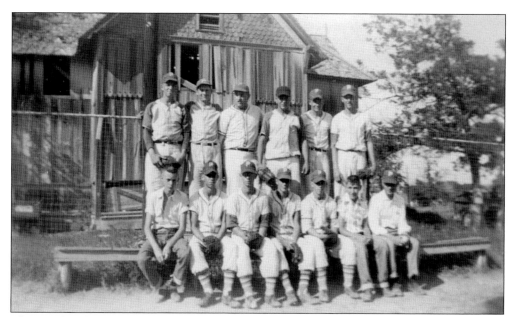

The 1950 baseball team, above, played on the field next to the old Schüetzen und Kegel Verein. Pictured from left to right are (first row) Don Lee Wolf, Milton Koch, Wayne Saegert, Alton Steger, Bobby Nauert, Jim Pennington, and coach Robert Hendrickson; (second row) Jimmy Saegert, Armin Wendland, Gene Gault, Stanley Lawrence, John Pfluger, and Norman Sansom. Below, the 1956 Little League team included, from left to right, (first row) Jimmy Mott, Charles Collier, unidentified, Lanier Bohls, Alan Vorwerk, Willard Hebbe, and (sitting) batboy Edward Bohls; (second row) coach Charles Kuempel, J.B. Marshall Jr., James Bohls, Eddie Imken, Joe Weiss, Edward Pokorney, Dwain Tom, Elwood H. Imken, Carroll Collier, and coach J.B. Marshall. Pfluger Hall was erected by volunteers on this site. Patience and commitment brought overwhelming and unexpected rewards. (Above, courtesy of HHM; below, Treldon Bohls.)

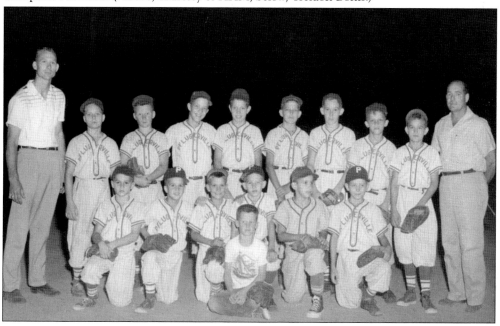

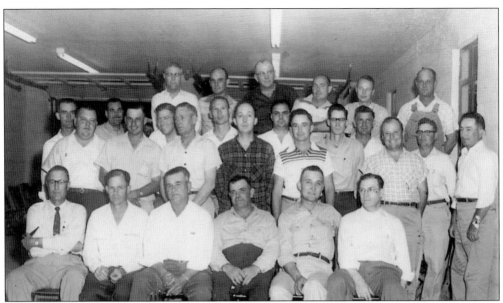

The volunteer fire department was chartered on July 6, 1955. Above are, from left to right, charter members (first row) Immanuel B. Krienke, Theodore Timmerman Jr., Otto Pfeil Jr., Arnold Arend, Alfred Mogonye, and Waldemar E. Pfluger; (second row) Johnnie Oscar Malmquist, Leon Pfluger, Albert Priem, Burwell Knebel, Clarence Bohls, Armin Pfennig, and Emil Bohls; (third row) Robert Fuchs, unidentified, A.G. Saegert, Charles Kuempel, Kermit Kuempel, Clarence Wieland, Willie Randig Jr., and Kennith Bohls; (fourth row) Walter Priem, Willard Pfluger, Otto Pfluger, J.B. Marshall Sr., Max Kuempel Jr., and Albert Remmert. Frequent fundraisers were held, with proceeds used to purchase the first fire trucks and fire-fighting equipment. The first one-ton fire truck cost $4,000. Below, annual barbeques, held at the fire station on Pecan Street, were well attended by the community. (Above, courtesy of HHM; below, V. Mott.)

In the 1983 photograph above, volunteer firefighters in their new uniforms are, from left to right, (first row) Larry Hodde, Lloyd Hebbe, Jerry Acevedo, Arthur "Bubba" Bartley, Elois Sakewitz, Johnny Davis, Mark Rogers, Noble Talley, Wilford Preusse, and Dave Wester; (second row) Mike Frick, Ron Mollenberg, Elton Sakewitz, Charles Kleen, Robert Weiss, Don Eugenis, John Wester, Fritz Hodde, James Riewe, and Bob Avant. The truck was purchased from the Austin Fire Department, refurbished, and returned to service. An annual fundraiser barbeque meal was prepared by the volunteers, with serving inside the station in 1956, seen below. Proceeds provided the necessary resources for the budget each year. Helmer Dahl was a one-man music entertainer with a broad selection of listening tunes for the folks that ate on trailers and tables outside. (Both courtesy of V. Mott.)

Patronize your home merchants and make Pflugerville a better a place to live in.	**Kuempel's Theatre** Pflugerville	Boost Your Home Town! If our community prospers, you prosper.

One Chapter of the Serial "GREEN ARCHERS" With Each of these Shows	March 1-3 Northwest Trail Joan Woodbury - Bob Steele MOUNTED POLICE STORY IN COLOR	Shows On THURSDAYS AND SATURDAYS Show Starts at 8:00 P. M.

March 8-10 Way Out West Stan Laurel - Oliver Hardy	March 15-17 Gypsy Wildcat Maria Montez - Jon Hall GYPSY STORY IN COLOR	March 22-24 That Texas Jamboree WITH HOOSIER HOTSHOTS	March 29-31 Enchanted Forest Edmund Lowe - Brenda Joyce FILMED IN COLOR
April 5-7 TEXAS WITH GLENN FORD	April 12-14 Abilene Town Randolph Scott - Ann Dvorak	April 19-21 ARIZONA Jean Arthur - William Holden ACTION! SUSPENSE! ROMANCE!	April 26-28 Last of the Mohicans Randolph Scott - Binnie Barnes
May 3-5 Stage Door Canteen Tallulah Bankhead Edgar Bergen - Charlie McCarthy	May 10-12 Kit Carson Jon Hall - Lynn Bari Action! Drama! Suspense!	May 17-19 Rolling Home Russell Hayden - Jean Parker	May 24-26 Dixie Jamboree Francis Langford Guy Kibbee
May 31 - June 2 Call of the Forest Robert Lowery Martha Sherrill	June 7-9 The Kansan Richard Dix June Wyatt	Admission Prices: CHILDREN 12 and under 9c, no tax ADULTS 21c, plus 4c tax 25c	

Rust's Tavern Bottle and Can Beer Enjoy a Game of Dominoes Your Business Appreciated	**Bohls Service Station** Seat Covers Batteries - Tires Washing Greasing	**P. B. K'S Place** Beer, Wine and Soft Drinks Cigarettes Tobaccos	**Aug. Dernhoefer** Staple Groceries And Frozen Foods

Kuempel's Theatre was located on Main Street between First State Bank and Imken & Neese Drug Store. It was a special treat to enjoy popcorn and a movie in a theater much closer to home than one in Round Rock, Austin, or Taylor. Admission was 25¢ (4¢ was tax) for adults and 9¢ for children. Pictured is a schedule for the Thursday and Saturday showings. (Courtesy of HHM.)

Hub Kuempel views a huge sign near the MKT Railroad tracks advertising the upcoming circus, a favorite event for the children of Pflugerville. It was an exciting occasion to watch the circus train travel through the city for the event under the big tent in Austin. To actually attend the circus was the highlight of the year. (Courtesy of Melanie Samuelson.)

A favorite pastime for all ages was playing dominoes, 42, skat, and canasta. From left to right are Matilda Smith, Mary Fuchs, Alfred Fuchs, and Emmitt Fuchs. Couples often met on Saturday night to play, and men frequently played a couple of games at the local tavern. The early Deutschen Pfests held competitive domino tournaments. (Courtesy of Treldon Bohls.)

Deer hunting in the Texas Hill Country was a popular sport for men. Automobile dealer Fritz Wieland (left) bagged a trophy buck, which he carried home tied to the hood of his automobile. Tales of adventures—and misadventures—were told as the ritual of making venison sausage followed. (Courtesy of Wieland family.)

Quilting offered women an opportunity to gather socially. While working together to stitch a special quilt top for a family gift, they shared news of family and friends. Many of the quilts were designed with special colors in mind, family memories, the names of children or parents, intricate patterns, and unique stitches. From left to right are Lorine Weiss, Erna Bohls, Ottile Fuchs, unidentified, Helene Pfluger, and Elda Pfluger. (Courtesy of Wieland family.)

Women passed their evenings crocheting, tatting, knitting, and embroidering, as well as making tablecloths, hankies, clothing, bedding, and wall hangings. Here, Blanche Bohls needlepoints while sitting in her rocker. Large trunks, as shown, stored treasured family heirlooms and linens. When the sewing machine became a household item, it provided new opportunities for making clothing from cotton feed sacks or with special fabric purchased at the mercantile. (Courtesy of Treldon Bohls.)

Seven

EMBRACING
OUR NEIGHBORS

Before Pflugerville became a village, the area in northeast Travis County was entirely rural. The Blackland Prairies provided the right conditions for farming. Small communities were Germanic enclaves that flourished, each with a one-room wooden schoolhouse, a church, and a general store. Once the railroad determined Pflugerville as the location for the depot, it became a center for business, banking, and entertainment for its neighbors.

Families from nearby Dessau and Gregg to the south, Center Point, Richland, and Cele to the east, Rowe to the north, and Three Point and Highland to the west were drawn to Pflugerville. Those who pursued a college education moved from the area to where jobs were more plentiful.

Common traditions of language, customs, and festivities, such as May Fetes, bonded the communities. Religious celebrations and rituals of baptism, confirmation, weddings, and funerals, as well as ethnic foods such as sauerkraut, *koffeekuchen*, dill pickles, herring, *kartoffel salat*, and bratwurst brought groups together. Traditional recipes, customs, and language were preserved for nearly a century. Families gathered for Sunday meals after church—men eating first, followed by the women, and finally the children—with dishes washed between each group. A common snack was fresh baked bread dipped in bacon drippings or sugared clabber.

When cotton crops dominated, gins were built at Cele and Center Point. However, some farmers brought their cotton to Pflugerville, where it was quickly ginned and cotton buyers were readily available for immediate shipping. In the ginning process, powered by a steam engine whose boiler was fueled by lignite, the hull was removed and the kernel was crushed to yield cottonseed oil. Fertilizer and feed were by-products.

While there were a few scattered early family cemeteries, churches had designated land, making the cemeteries a permanent site that remain intact long after other remnants of a community have disappeared.

Few of the small communities remain today, as farmland has become housing developments for the spreading cities of Pflugerville, Round Rock, and Austin; however, each community is part of the heritage that has woven the fabric to what is here today.

Martin Wieland, from Dessau, Germany, landed at Galveston in 1854, traveling to central Texas by ox team and wagon. Settling 12 miles north of Austin, he named the new community Dessau. He lived in a tent until his fieldstone home with 18-inch walls was built. Other German families settling here included Nauert, Nehring, Grosskopf, Krueger, Hennig, and Goerlitz. Members of the community, who donated the materials, constructed Evangelical Lutheran Church of Dessau in 1876. The small wooden church, located at Dessau Road and Howard Lane, remains a landmark. Many of the early settlers are buried in the church cemetery. Dessau School, a one-room wooden building, was located near the church. The first meeting hall (below), Halle der Germanus Sohme, built by Sons of Hermann, was located across the road. (Above, courtesy of V. Mott; below, Knebel family.)

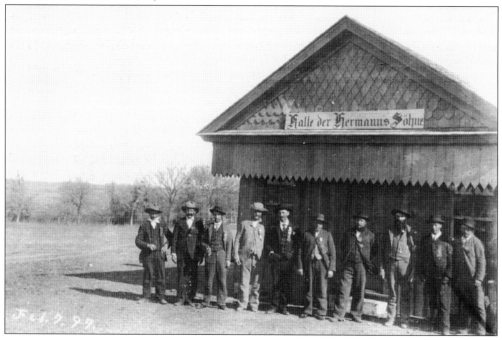

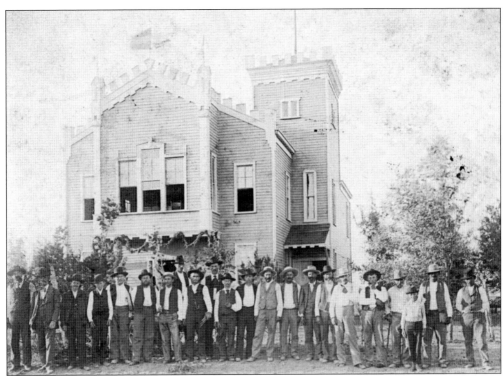

House dances were common and often came along with Schnapps to drink. By the late 1800s, a new two-story hall was built, known as Dessau Hall (above). Burned down in 1940, it was replaced by a one-story building with a huge pecan tree in the middle of the dance floor. Again destroyed by fire in 1967, a modern structure occupies the site today. Music has played a significant role, with men playing many instruments, including the harmonica, and women the pump organ or piano. The Dessau Band of the 1890s (below) and big bands such as Glenn Miller, Woody Herman, and Tommy Dorsey, as well as popular country singers like Bob Wills, Hank Williams, Patsy Cline, and Jerry Lee Lewis, have played at Dessau Hall. Other dance venues included Skyline, Eggers, S.P.J.S.T., and Westphalia. (Above, courtesy of Knebel family; below, Martha Sansom.)

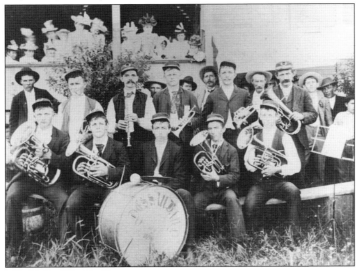

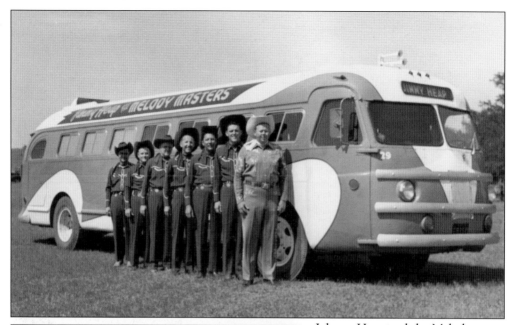

Johnny Heap and the Melody Masters (above) performed across Texas. They recorded "Dessau Waltz," written by Horace Barnett and Arlie Carter, which was put to a nameless tune and named for the hall they frequented during the 1940s. Area residents tuned in daily to hear the band's popular tunes on radio station KTAE in Taylor. From left to right are Peck Williams, George Harrison, Cecil Harris, Arlie Carter, Horace Barnett, Bill Glendening, and Jimmy Heap. At left, a new performer, Elvis Presley, brought his rockabilly music to the hall in 1955 with bassist Bill Black (right) and guitarist Scotty Moore (not shown). (Above, courtesy Paul Schlesinger; at left, Steve Bonner.)

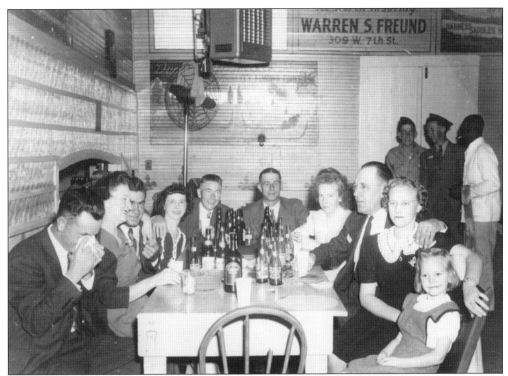

In the 1950s, Dessau Hall was a popular location for birthday parties, celebrations, and joining friends for entertainment. Above, the Schoens, Fleischers, and Wittenbergs gather for long necks and dancing. Couples wiggled, giggled, and boot-scooted across the floor slick with cornmeal. Honky-tonks came later and were not appropriate for children. Below, cousins Clarence (left) and Kennith Bohls enjoy popular Lone Star beers while listening to live music at Dessau Hall. During the early years, the Dessau General Store was located next to the hall. (Above, courtesy of Herbert Wolff; below, Clarence Bohls.)

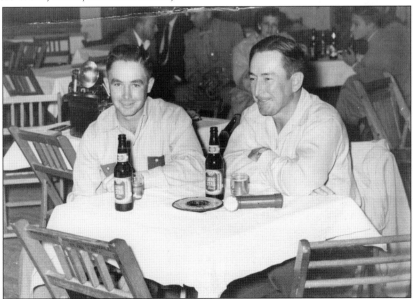

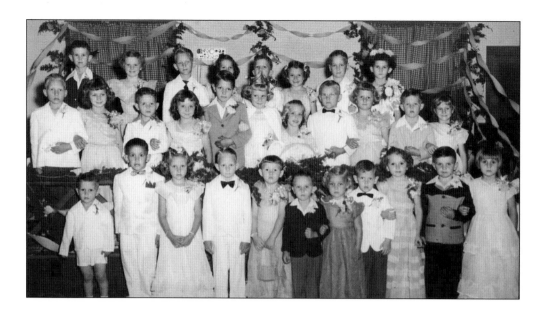

May Fete was celebrated each May under the massive pecan trees at Dessau Hall. The festivities brought the community together for an evening of dancing and fellowship. Above, the 1952 Tiny Tot May Fete queen, Kay Weiss (center), is escorted by the king Joe Weiss (to the left of Kay, in the gray coat). Below, 1955 May Fete queen Gladys Pokrant (right center), surrounded by her court, is seated next to king Don Weiss. The German tradition is held at the beginning of planting season. Traditionally, children dance around a Maypole, creating a beautifully woven pattern with the vibrant streamers. The more beautiful the pattern, custom has it, the more bountiful the crop. Octoberfest is held in the fall to celebrate the harvest. (Above, courtesy of HHM; below, Gladys Weiss.)

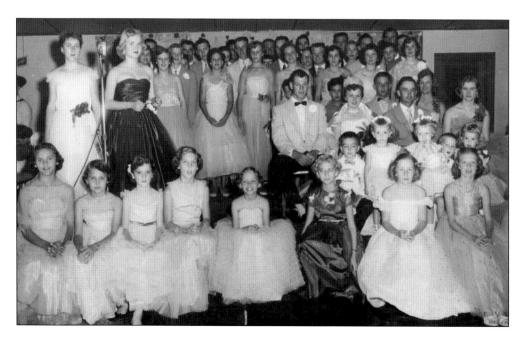

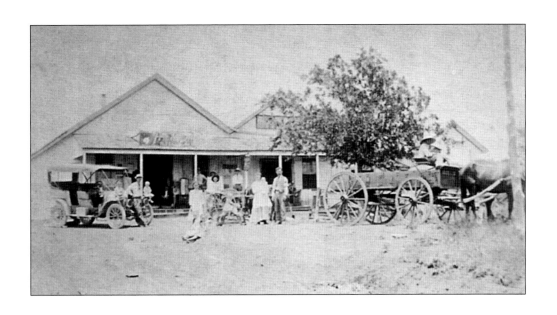

The Cele Store, above, was a trading post in 1890; it was bought in 1903 by Magdelena Oertli Steger and sons Leonard and Fred, with Will taking ownership in 1908 and then Fred in 1912. A booming business, it was enlarged, and served the area until the 1940s. A gristmill (corn ground every Friday), icehouse, and blacksmith shop were added. The mercantile sold fancy apparel, staple groceries, notions, drugs, hardware, saddlery, crockery, coffins, and numerous necessities until business declined during the Depression. Leonard later owned the Pflugerville store. The Stegers emigrated from Germany to Massachusetts in 1864, arriving in Richland in 1877. Below, Henry and Emma Sakewitz Steger were married in 1898 with a celebration of family and friends at the Steger home. In the center, the bride wears a traditional black dress adorned with a white veil. Parents of each are seated on either side of the couple. (Both courtesy of Hildegarde Gebert.)

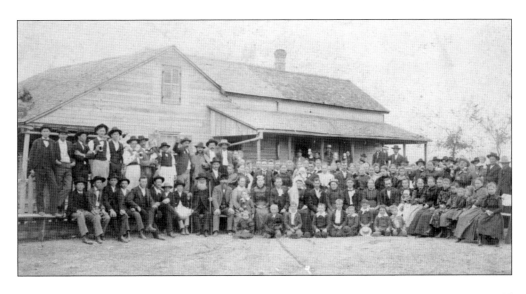

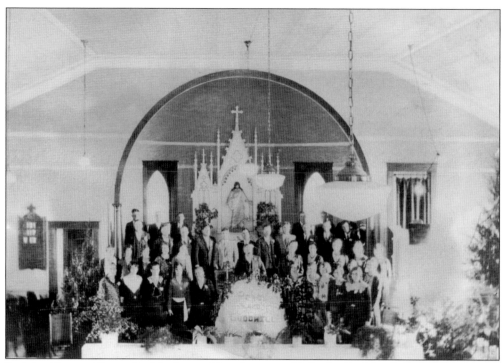

St. John German Evangelical Lutheran Church was established in Richland, east of Pflugerville, in 1878. A small sanctuary was completed in 1884, using wood from an old ranch house in the area. When the new sanctuary was completed in 1891, the old building was converted to a pastor's residence. Designed by John Wuethrich of Taylor, the current building was constructed by F.J. Sefcik in 1925 for $20,000. The adjacent parish hall was built in 1939 and the parsonage in 1955. Above, the Christmas cantata shows the interior of the sanctuary. Below is the renowned 1935 church orchestra, directed by Pastor Julius J. Kasiske, who served for 21 years. A few of the family names in the area include Gonzenbach, Gebert, Wendland, Vorwerk, Hodde, Hamann, Dossman, Mahlow, Engelmann, Prinz, Sakewitz, Kerlin, Klotz, Melber, and Stern. (Both courtesy of Hildegarde Gebert.)

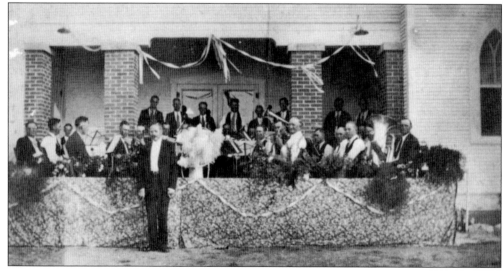

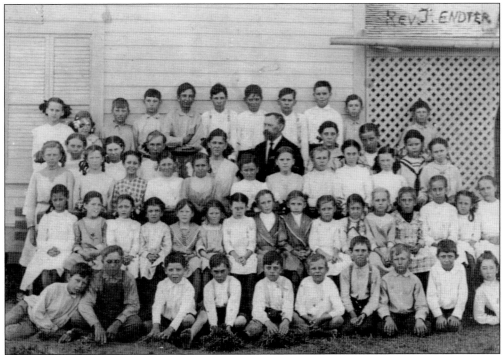

In 1877, Franz Schmidt Jr. and his wife, Marie Pfluger, saw the need for education in the Richland area and offered their home as a school. Under his direction, a one-room school was erected in 1878 on an acre of land he donated. In 1881, the schoolhouse, also used for worship services, was sold to an individual and the money applied to the construction of a new building in 1883. In 1905, voters agreed to enlarge the building and make it a two-teacher school. A separate room was annexed in 1920 and a third teacher added. Above is the 1911 Richland class. Below is the school in 1936, with the church and parsonage in the background. The Richland Colored School was located at the corner of Schmidt Lane and Cameron Road. (Above, courtesy of Lamar Weiss; below, Hildegarde Gebert.)

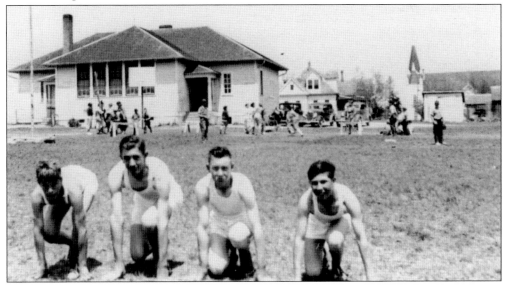

Sons of Hermann, a German fraternal insurance group, granted a charter to Richland in 1894. Germania Hall, now Richland Hall, was constructed shortly after the land was purchased on Cameron Road in 1898. The oldest active community hall in Travis County, it is still available to rent today. Rules for the old Germania Hall are still displayed, forbidding smoking and the wearing of spurs or hats. With exterior concession stands and a gravel parking lot, the Richland Community Club hosts the annual May Fete. Above is the 1947 queen, Waldene Gonzenbach, and king, Gilbert Weiss. Below, the 1957 queen, Joylene Mahlow, is with her court while children wrap the maypole. Decorations for the event were clipped branches of cedar trees decorated with flowers made of tissues. (Above, courtesy of V. Mott; below, Clifford Ward.)

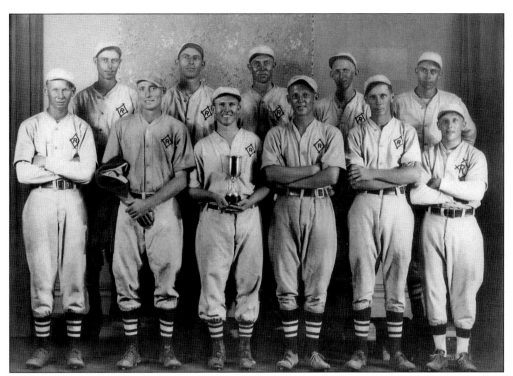

Above, the Richland Eagles baseball team shows off their trophy in 1935. The team included pitchers Peacher Hodde, Smokey Hees, and Cap Kuehner, who often heard supporters cheer in German on Sunday afternoons. During that decade, the team won five Cup Races, sponsored by the *American Statesman* newspaper for community baseball. Games were played near Cele Store and pay was beer, cheer, and sheer pleasure. In 1935, Richland schoolchildren, at right, donned homemade crepe paper dresses for a special program. From left to right are (first row) Lorine Gebert, Mildred Gebert, and Gertrude Prinz; (second row) Junette Wieruscheske, Alvina Hodde, Doris Hees, Aleta Fuchs, Elinor Schmidt, and Josephine Steger. (Above, courtesy of HHM; at right, Hildegarde Gebert.)

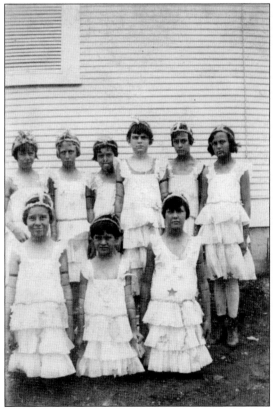

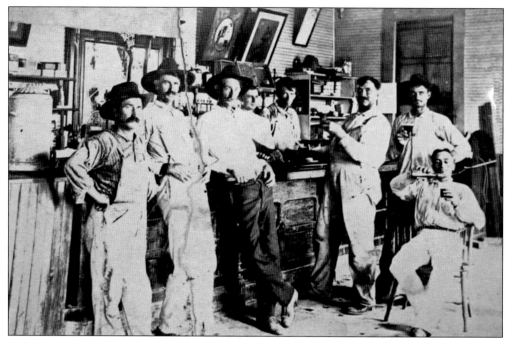

The Richland Saloon, above, was built in the 1890s to serve the communities of Richland and Cele. The name Cele is attributed to first owner Seth Custer's daughter, Lucille. Now known as Cele Store, it has been a watering hole, a gas station, grocery, fertilizer dealer, and award-winning barbeque eatery. Marvin and Marilyn Weiss purchased the store from Ewald Weiss in 1951. The original bar still attracts visitors. In 1920, before Prohibition was enacted, several men rode horses into the building to express their displeasure at the ban on alcohol sales. The sign below directs visitors west to Merrilltown. Founded by Texas Ranger captain Nelson Merrill in 1837, the post office served Pflugerville until 1893. Alex Klattenhoff, a World War I Purple Heart recipient, purchased the 414-acre Herman Fleischer homestead in this area, which today is Wells Branch. (Above, courtesy of Frances Gibich; below, Treldon Bohls.)

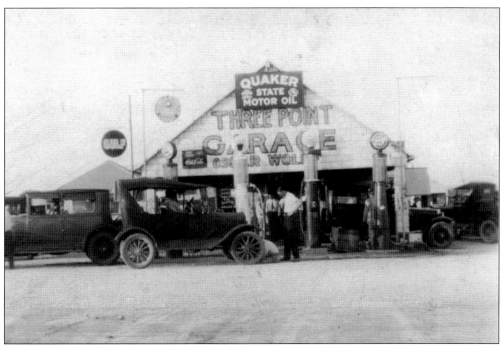

Three Point Garage, above, was built in the 1920s by Oscar Otto Wolff and his sons at the intersection of the three roads from Austin, Pflugerville, and Round Rock. The family operation faced highway US 81 and Pflugerville Road (now Vision Drive and FM 1825) and served as a Greyhound bus stop. A hamburger stand was added in 1929, selling hamburgers for 10¢ and sodas and candies for a nickel each. The family sold the station to Arthur P. Luke of Taylor, who later sold it to Magnolia Oil Company. "Hobos" would frequently stop to ask for food. Below is the 1949 service station, which was modernized in the late 1930s. Charlie's Steak House converted the building in 1972, serving tasty home-style meals for nearly four decades. (Both courtesy of Herbert Wolff.)

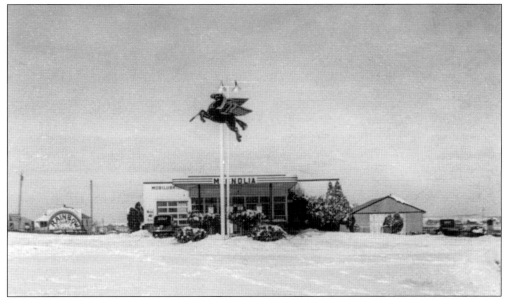

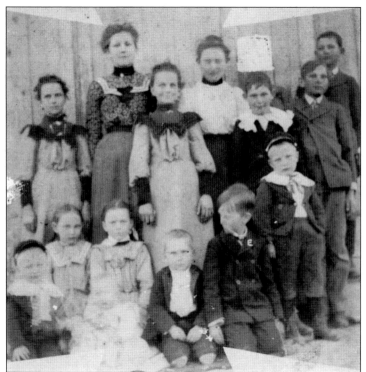

The 1890 class of Center Point School had one teacher for all grades. The school was later moved to Pflugerville, serving as a homemaking classroom and, later, band hall. (Courtesy of Gladys Pfluger.)

Children of the Weiss, Fuchs, Pfluger, and Bohls families at Center Point School enjoyed games such as dodgeball, red rover, wolf across the river, hide and seek, andy over, drop the handkerchief, and baseball, as well as fun on the swings, see-saw, and merry-go-round. Children of other rural families, such as the Klattenhoffs and Priems, attended Rowe School. (Courtesy of Treldon Bohls.)

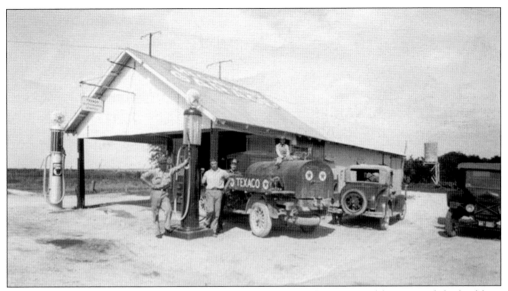

Arnold and Marie Wieland Fleischer farmed in the Highland area. Arnold witnessed the building and dedication of the Texas capitol in 1888, when 20,000 visitors converged on Austin. Highland Garage, built to accommodate travelers on US 81, provided patrons with a service station, a tavern (a cold beer cost 20¢), and a pinball machine until 1967. From left to right are Fritz and Alvin Fleischer, Texaco dealer B.O. Doerfler, and an unidentified individual. (Courtesy of Treldon Bohls.)

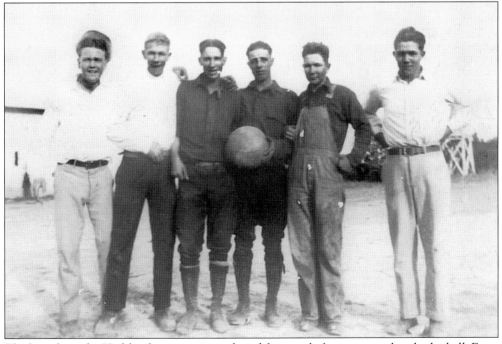

The boys from the Highland community gathered frequently for games, such as basketball. From left to right are Albert Wolff, Erwin Schoen, Herbert Wolff, Fritz Fleischer, Fritz Schoen, and Herbert Schoen. In addition to the these names, children from the Hebbe, Sessler, Hohertz, and Priem families attended Highland School, which was located near the intersection of Vision Drive and Foothill Farms. (Courtesy of Herbert Wolff.)

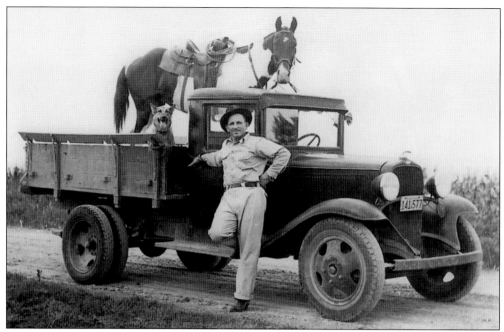

Ernest Acklin, who owned and operated the Acklin Chevrolet dealership in Manor, assisted in securing the first fire truck for the Pflugerville Volunteer Fire Department. Manor is named for James Manor, who settled nearly 2,000 acres from land grants received in the 1850s. Manor and Pflugerville-area residents organized to form the Manville Water Supply Corporation, providing residents with good, clean water. (Courtesy of Kuempel family.)

Bird's Nest Airport, a local airport for more than 40 years, served single-engine planes, training pilots and parachute jumpers. Here, Steve Jackson and Vaughn Rupple jump in 1973. In 2007, Ron Henriksen of Houston purchased the airport and surrounding property, replacing the grass and gravel landing strip with concrete and expanding the runway to accommodate jets. Austin Executive Airport now serves general aviation for the metropolitan area. (Courtesy of Alan Coovert.)

Eight

MAKING A DIFFERENCE

The spirit of giving back, a valued trait of the settlers to this area, has continued throughout the decades. Their can-do attitude supported efforts to farm the rich land. They appreciated the importance of working together to serve their community and their country. Settlers made a difference by immediately establishing churches to practice their faith, schools to educate their children, and businesses to offer residents the necessary services and goods.

While men were commonly applauded for their service to country and community, women also made a difference. They worked in the fields next to the men, returned to the farmhouse to prepare hot meals to feed the hungry workers, and returned to the field to continue the work. Their work was never done. Women served their country by enlisting for military service, working in jobs vacated by the men who went off to war, and by keeping the home farms and businesses running during difficult times. Farms typically passed from generation to generation, with families leaving a legacy of their rich heritage, laced with rich traditions.

Men and women gave back to their community, and their country, by serving in publicly elected positions, such as school boards, city councils, commissions, committees, and government jobs. In addition, they organized non-profit organizations, supporting churches, schools, libraries, city offices, people in need, and health clinics. Others made a difference by entertaining residents, offering their homes as movie locations, making classic movies still enjoyed today, and recording cultural music.

This chapter includes only a few examples of dedicated individuals and organizations that have made a difference in the Pflugerville community over the past century exhibiting, with pride and honor, the determination of past generations. Pflugerville is fortunate to have a population with a generous spirit that understands the importance of giving back.

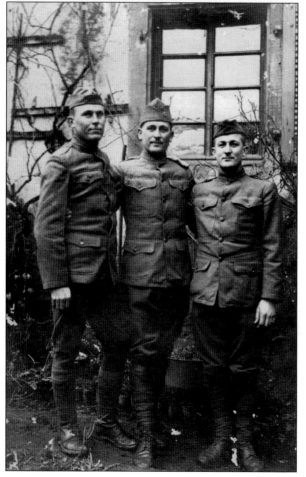

During World War I, women served their country by joining the Red Cross. Providing medical and recreational services, they also established a Home Service Program to help military families. Red Cross nurses served as ambulance drivers and collected blood donated for the wounded. Shown here are sisters Elda (left) and Dora Pfluger in 1918. (Courtesy of Lamar Weiss.)

Young men volunteered, or were drafted, for the armed forces. Henry Bohls (left) and his Pfluger cousins, brothers Bruno (center) and Dudley, trained at Fort Sam Houston in San Antonio before being deployed to Europe in World War I. All returned home safely. Henry farmed his homestead and served on the school board; he lived to be 101. Bruno Pfluger Construction built homes in town. Dudley was a carpenter and sang in the church choir. (Courtesy of Lamar Weiss.)

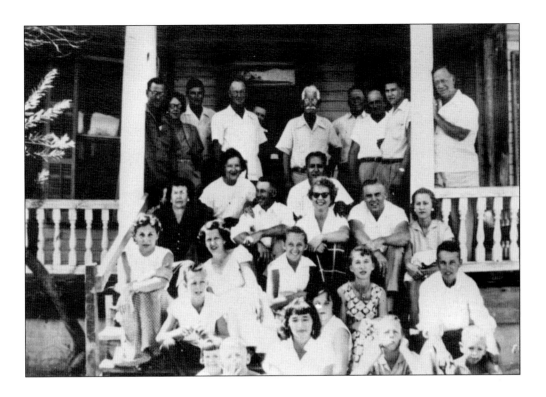

Pictured with his family, Charles C. Kuempel (with the white mustache) was a farmer and rancher, a banker for 25 years—making loans based on character first and collateral second—the justice of the peace for 20 years, and served the school district. A highlight of his career was the bank being selected as a depository for Travis County. In the 1930s, the Civilian Conservation Corps (CCC), also known as the Works Progress Administration (WPA), part of Franklin D. Roosevelt's New Deal, established a camp here. CCC Camp No. 3809 (below) was built on this farm. The 300 men in the camp helped build terraces in the fields to provide soil conservation, constructed concrete structures in the drains from the terraces to prevent erosion, and erected the Rock Gym, which is still in use today. (Above, courtesy of Max Kuempel family; below, Clifford Ward.)

To support the national effort to meet the demand for metal needed in World War II, scrap metal was collected in front of the school. An old iron bridge over Gilleland Creek was contributed to the project. Schools regularly practiced air-raid drills, fearing an enemy attack. War-ration booklets were issued for sugar, gas, tires, and other commodities; war bonds were purchased to help the cause. (Courtesy of Treldon Bohls.)

After serving in Iwo Jima as a cryptologist during World War II, Marion Pfluger attended the University of Texas on a golf scholarship. Coached by Harvey Penick, he won all his matches from 1947 to 1950 and played in three National Collegiate Athletic Association championships, losing only to Arnold Palmer. He was awarded the 1966 Professional Golfers of America Man of the Year for mentoring future golf champions during his career. (Courtesy of Jeanette Burke.)

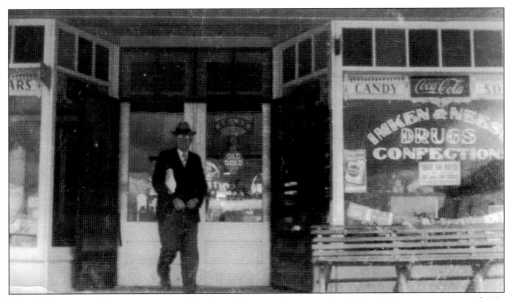

John Neese served as postmaster, wheeling the postal cart to the sidewalk for access to mail. He taught at Rowe and Carrington schools from 1902 to 1904. Elected secretary of the school board in 1905, he was instrumental in building the 1907 school. A self-taught and registered druggist for nearly 46 years, he owned the Imken & Neese Drug Store, built in 1909 on Main Street, until he died in 1963. (Courtesy of Robert Johnson.)

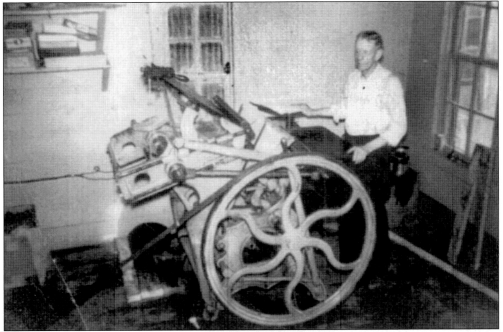

Albert W. Goerdel kept the community informed on local, state, and national events in his weekly publication of *The Pflugerville Press*. From 1907 to 1942, it was the only newspaper published in Pflugerville and the only weekly newspaper in Travis County, with only two issues missed due to illness. The press was at Pecan and Paul Streets, east of the tracks and adjacent to Siegmund's Garage. (Courtesy of HHM.)

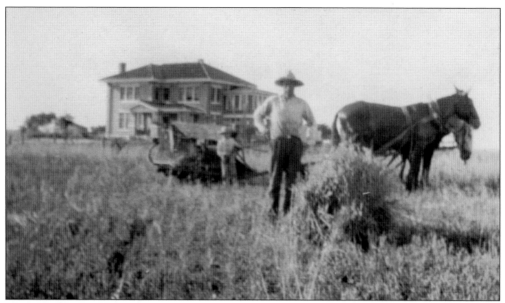

Theodor "Te" Timmerman Jr., as a young lad, and his father, Theo, work together at the homestead. Both engaged in farming and ranching and eventually became major landowners. Te's volunteer service included tenure on the Immanuel Lutheran Church Council, Travis County Appraisal Board, Manville Water Supply Corporation board, the Pflugerville Volunteer Fire Department, and 21 years on the school board. Timmerman Elementary School is named in his honor. (Courtesy of Harriet Hocker family.)

The German American Mutual Assurance organized as a non-profit in 1891 with a purpose to provide fire and extended coverage for rural farm buildings and equipment. Signers of the constitution represent families in the greater area. It remains the oldest business in Pflugerville, serving central Texas with 1,026 members and $151 million insurance in force. Otto Bohls Sr. served on the board for 35 years, including over 24 years as president. (Courtesy of Clarence Bohls.)

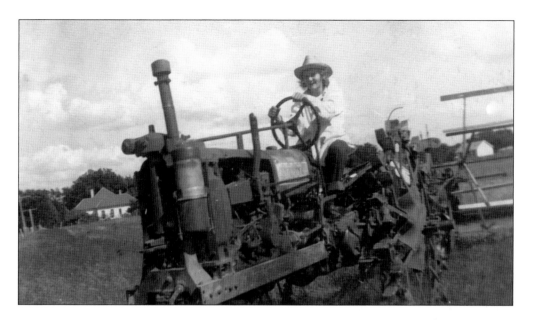

Gladys Pfluger, above, and her husband, Leon, generously donated the family's popular Fritz Pfluger Grove on Gilleland Creek to the City of Pflugerville. Fritz was a founder of the first bank. The grove was the beginning of the extensive parks system that now comprises over 1,100 acres of beautiful parkland and more than 30 miles of public trails winding throughout the city. As in the past, the park provides a perfect setting for school picnics, worship services, reunions, community events, summer programs, and outdoor activities. Below, women were of strong grit as they prepared and brought hot meals to field workers. Not only responsible for bearing and raising large families, they worked side by side with extended family and neighbors in the fields, church, and community. Over the decades, they became more liberated. (Both, courtesy of Gladys Pfluger.)

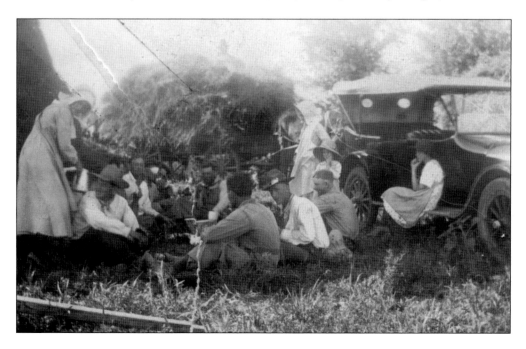

Ed Knebel owned the Pflugerville Bottling Company before selling it to establish the Nehi drinks at 7 Up in Austin. His passion for baseball led him to form the Austin Pioneers, a minor-league club, and build Disch Field. Knebel (far left) is pictured with Texas governor Allan Shivers (center), and baseball promoters. (Courtesy of the Knebel family.)

Associated with the State Council on Dental Health, and president of the Austin District Dental Society as well as the Pflugerville School Board, Dr. Otis Watson fits football player Charles Mott with a customized mouth guard, which he and Dr. John Stone made to protect athletes from injuries to the mouth and jaw in 1957. Jerry Nelson is on the left. (Courtesy of V. Mott)

Clarence Bohls, a farmer for four decades and fertilizer businessman for 17 years, was instrumental in the incorporation of the city as a General Law City in 1965. He served in numerous positions, including mayor from 1976 to 1982 and later as city administrator. He was instrumental in the purchase of the waterworks and the first wastewater treatment plant. He served as Deutschen Pfest parade marshal in 1978. (Courtesy of Treldon Bohls.)

Fannie Mae Caldwell, at age 102, cuts the ribbon dedicating the elementary school named in her honor because she was a beloved advocate of education. Her efforts resulted in bus transportation for African American students. Behind here are, from left to right, (first row) Glen Caldwell, Charles Caldwell, and Kenneth Thompson (the first African American trustee); (second row) Ronnie Caldwell, Dr. Libby Gardner (the first female superintendent), Elaine Boozer (first female trustee), and Cindy Gee (principal). (Courtesy of PISD.)

Winnie Mae and Jack Murchison were awarded the 1996 Citizen of the Year from the Greater Pflugerville Chamber of Commerce. Jack served on the school board for 12 years and was a lifetime member of the Lions Club; Winnie Mae served the school district for over 30 years. Their home served as the site of numerous films, including the popular *Best Little Whorehouse in Texas*, starring Dolly Parton and Burt Reynolds. (Courtesy of Winnie Mae Murchison.)

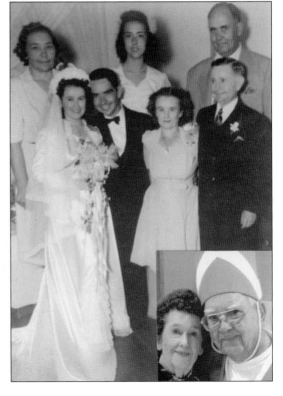

Clarence Swensen brought joy to millions as a munchkin soldier in the 1939 classic film *The Wizard of Oz*. The 4.5-foot tall Texan joined other former munchkins in 2007 to be honored with a star on the Hollywood Walk of Fame. Swensen married Myrna in 1945; her plans to join the cast of *Oz* were crushed by an emergency appendectomy. Her father, John Clifton (front, right), was the original Buster Brown. (Courtesy of Myrna Swensen.)

Established in 1982 by the Friends of the Pflugerville Library, the first library opened in a small storefront on Railroad Avenue. The organization gifted the library collection and 1.6 acres to the city, where it built a 12,500-square-foot facility. Above, at the 1999 dedication are, from left to right, Nancy Pruitt, Audrey Dearing, Nadine Whiteley, and Texas first lady Laura Bush. In 2013, it was expanded and renamed the Pflugerville Public Library. The "Window to the World," 16 four-foot square panels of stained glass adorning the south wall of the library, was a gift to the city by the Friends of the Pflugerville Library in 2004. At right are designer Jan Spears (left) and Ray Kraemer. Kraemer, a retired Lutheran pastor and artisan, constructed and installed the window, assisted by Treldon Bohls and Scott Spears. (Above, courtesy of Audrey Dearing; at right, Jan Spears.)

The Heritage House Museum is housed in the Gottlieb William Bohls home (above), located on the Old Hutto-Austin Highway. The Bohls's children are, from left to right, (first row) Leon and Fred; (second row) Lucile and Alvin. The Bohls deeded the property to the city in 1992 to preserve and promote the city's heritage and culture. The Queen Anne/Free Classic–styled home, built in 1913, is open the first Sunday of each month. The museum is hosted by volunteers and maintained by the city. Special exhibits and events, such as the Christmas carolers (below), are held during the year to generate community interest and promote the rich local history. The Farmers Market offers fresh produce during the harvest season in the Green Red Barn on the property. (Above, courtesy of Clarence Bohls; below, HHM.)

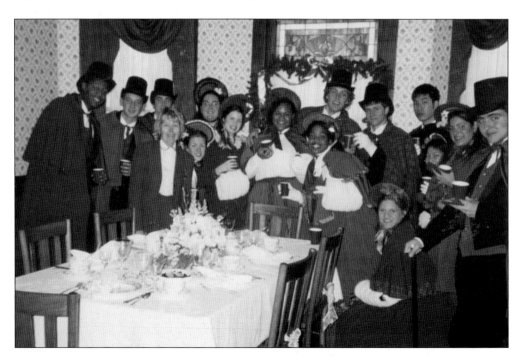

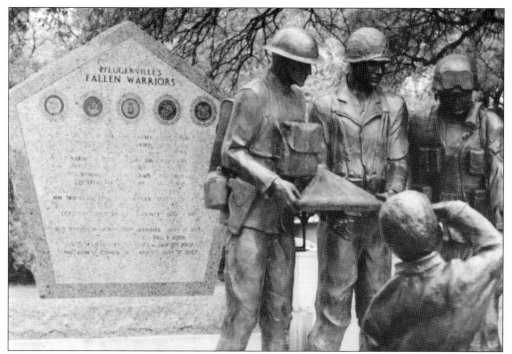

Honoring those who have given the ultimate sacrifice for their country, the community erected the Fallen Warriors Memorial, seen above, in Pfluger Park. Designed by resident Britta Herzog and sculpted by artist Cindy Burleson, the life-size bronze sculpture depicting three generations of soldiers was dedicated in 2005. The bronze of a young boy saluting the soldiers was added later. Names of the fallen appear on the granite monument. Below, the 180-acre reservoir forming Lake Pflugerville was completed in 2006, providing area residents water from the Colorado River and a recreation destination. From left to right are David Buesing, city manager and first police chief; Patricia Gervan-Brown, president of the chamber of commerce; Mayor Cat Callen, the first female mayor of the city; Ron Beyer, councilman; Kelly Kaatz, HDR engineer; Rick Murphy, director of Pflugerville Community Development Corporation; and Greg Miller, manager of Round Rock Express. (Above, courtesy of Pat McCord: below, City of Pflugerville.)

DISCOVER THOUSANDS OF LOCAL HISTORY BOOKS
FEATURING MILLIONS OF VINTAGE IMAGES

Arcadia Publishing, the leading local history publisher in the United States, is committed to making history accessible and meaningful through publishing books that celebrate and preserve the heritage of America's people and places.

Find more books like this at
www.arcadiapublishing.com

Search for your hometown history, your old stomping grounds, and even your favorite sports team.